FIND MOMO

MOMO

COAST TO COAST

MY DOG IS TAKING A ROAD TRIP.
CAN YOU FIND HIM?

Another hide-and-seek photography book by Andrew Knapp

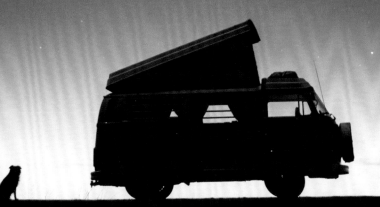

QUIRK BOOKS
PHILADELPHIA

FOR INSTAGRAM

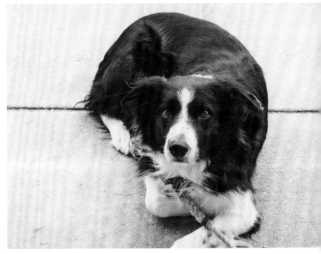

Copyright © 2015 by Andrew Knapp

All rights reserved. No part of this book may be reproduced in any form without written permission from the publisher.

Library of Congress Cataloging in Publication Number: 2014938243

ISBN: 978-1-59474-762-5

Printed in China
Typeset in Sentinel and Trend Sans

Designed by Andie Reid
Photography by Andrew Knapp
Editorial assistance by Jane Morley
Production management by John J. McGurk

Quirk Books
215 Church Street
Philadelphia, PA 19106
quirkbooks.com

10 9 8 7 6 5 4 3 2 1

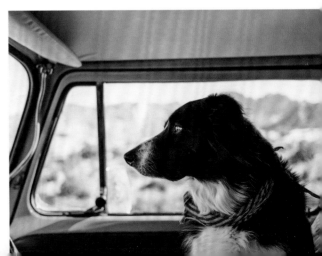

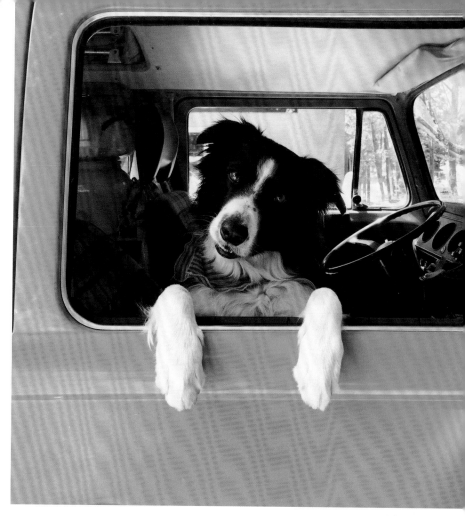

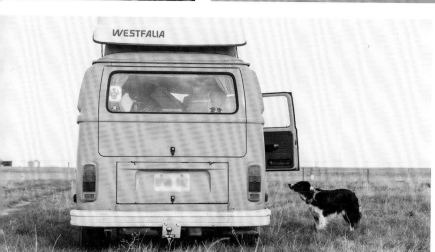

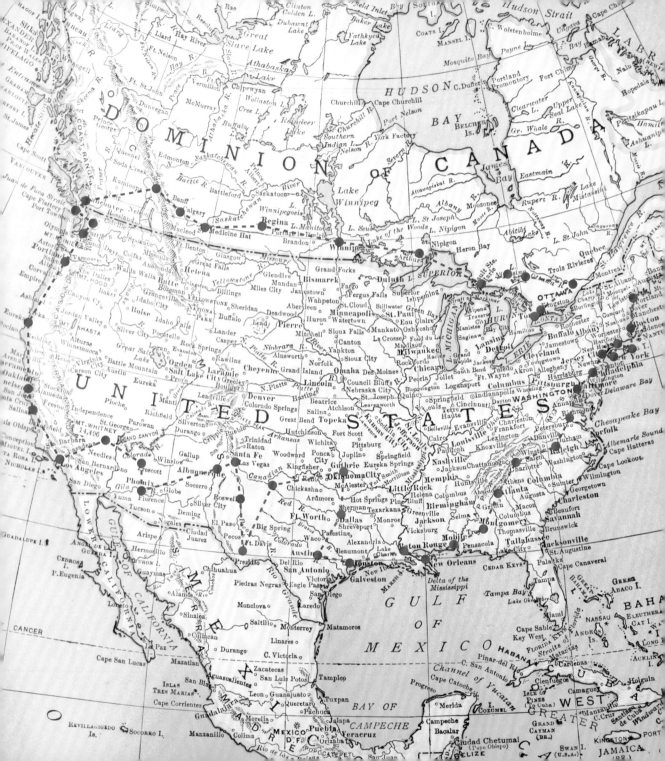

ROAD MAP

ON THE ROAD

Adventure occurs when we embrace change.

In November 2013, with the sale of my house finalized and my entire life now contained within an adorable 1977 Volkswagen Westfalia van, I made a decision to expedite change. My border collie, Momo, and I sat in the front seats and left my hometown for a twenty-five-state, five-province tour of North America.

I was geared up to explore and to share *Find Momo,* my first book. (To recap: Momo became a bit of a sensation a few years back as the star of an Instagram game of hide-and-seek photography.) Through-out our 15,000-mile trip, many guests made themselves comfortable in the VW. But the ideal travel companion was always Momo. He stays close when it's cold, keeps watch while it's warm, and is completely at peace with a wrong turn or a breakdown.

In this book is a game we love to play with all of you. I hope it will awaken and strengthen your own innate desire to explore. In exploring, we discover; in discovering, we become inspired; and with inspiration, we create. Momo is always leading me to new adventures, new places, new ideas.

This book is a game of hide-and-seek, a record of our exploration, and a review of the journey . . . which was, of course, the destination.

5

the EXPLORERS CLUB
GRAND HOTEL

A GUIDE TO FIELD IDENTIFICATION

BIRDS
of North America

Bay Area Oral and Facial Surgery
William Tam, DDS, MD, Inc.
Oral & Maxillofacial Surgery

MILK-BONE

White Sands

WOOF

SMOKING STINKS

TRAVEL SOUVENIRS, FROM UPPER LEFT:

"5" TILE: from an abandoned waterpark. CDS: from musicians we met. BIRDS OF NORTH AMERICA: picked up at a thrift store. STONES: from Long Island, near Montauk. YELLOW VAN: from our friend Faye in Toronto. BELL: from our friend Katie in Alberta, after the van's horn stopped working. LONE STAR BANDANA: from a lovely fan in Austin, Texas. CLAW: found onshore in western Ontario by our friend Jupiter. "SMOKING STINKS" BUTTON: from a thrift store. DOG TREATS: I collected so many I had to start giving them away! POCKET KNIFE: from a thrift store in Canada. BROCHURES: from various national parks. BONE: probably deer or moose, found in central Canada by our friend Katie. MANY BUSINESS CARDS: the one that's visible here is from a dentist in San Francisco who pulled my tooth. REBATE COUPON: from Drive-Thru Tree Park in California. VIEW-MASTER: found at an estate sale in Connecticut. BORDER COLLIE FIGURINE: from Rick at Quirk Books in Philly.

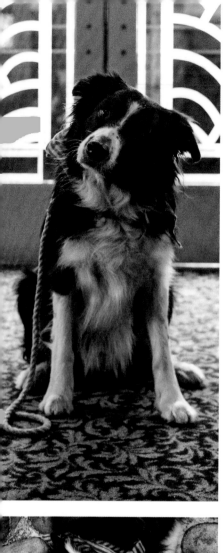
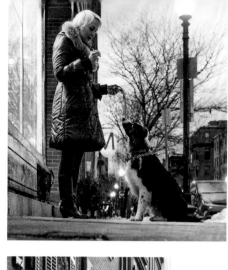
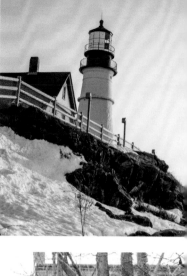

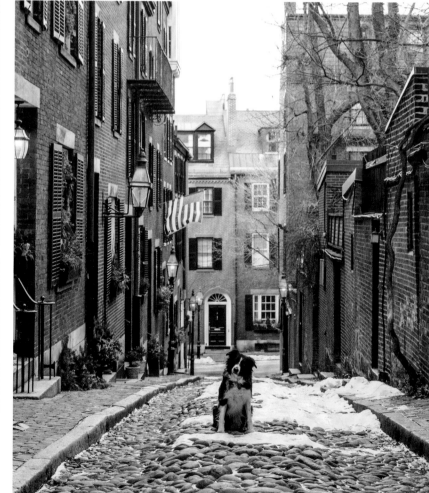

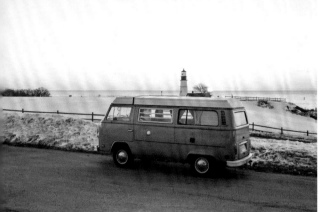

NEW ENGLAND

Our coast-to-coast sojourn began on a cold morning in Portland, Maine. As if my northern hometown of Sudbury, Ontario, was sending me a parting gift, I woke up to outdoor temperatures of about -20°F (-30°C). But light from the not-yet-over-the-horizon sun was brightening our motel window, so Momo and I cracked out of bed to check out Portland Head Light at sunrise.

 We pulled up to the lighthouse just as the sun peeked over the horizon. We hopped a fence and scaled some rocks and found a neat little hiding spot. Momo's white fur glowed orange in the sunlight. I snapped a photo. "All right," I said, "Let's get out of here." We had a continent to cross.

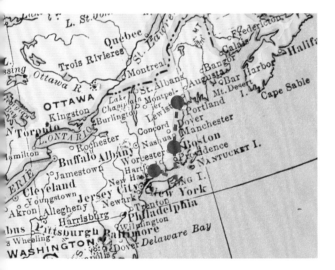

(*opposite, clockwise from top left*) At the Coolidge Corner Theatre in Brookline, MA; our friend Cara with Momo in Boston; Portland Head Light, Cape Elizabeth, ME; our van, "Mellow," at Portland Head Light; our route; Momo in Portsmouth, NH; two views of Acorn Street in Boston.

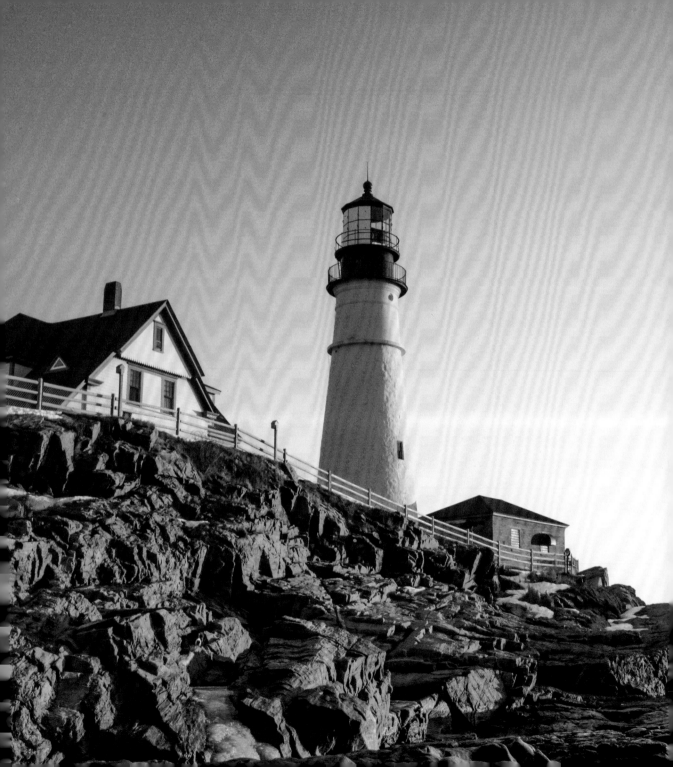

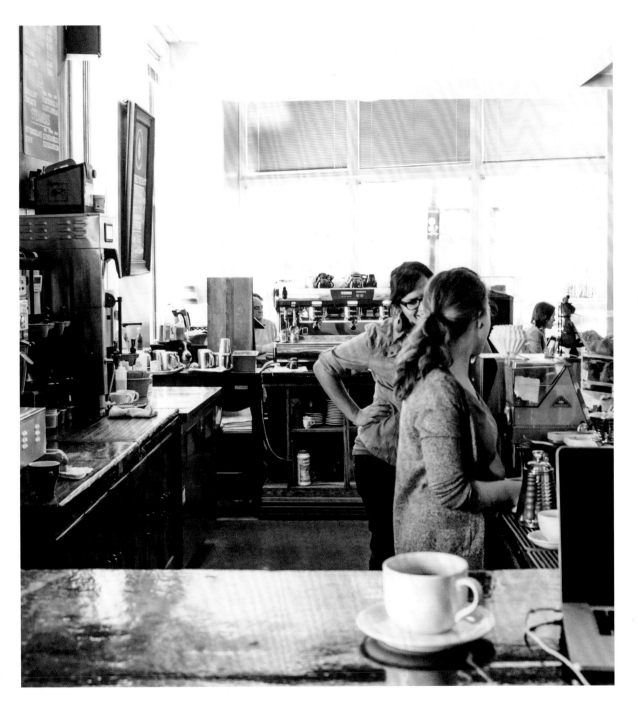

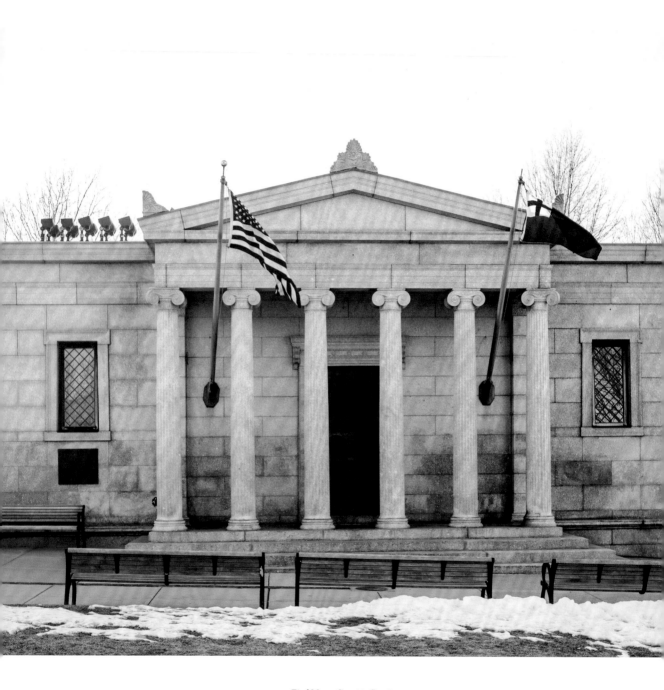

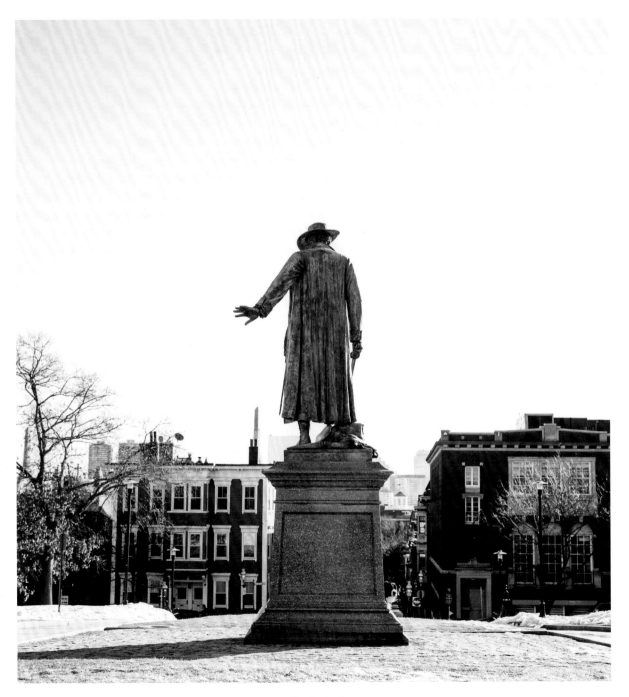

New England

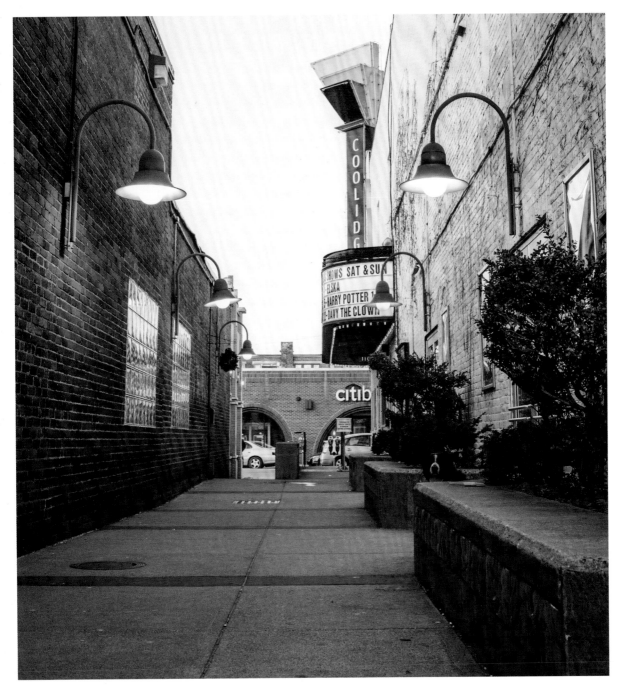

New England

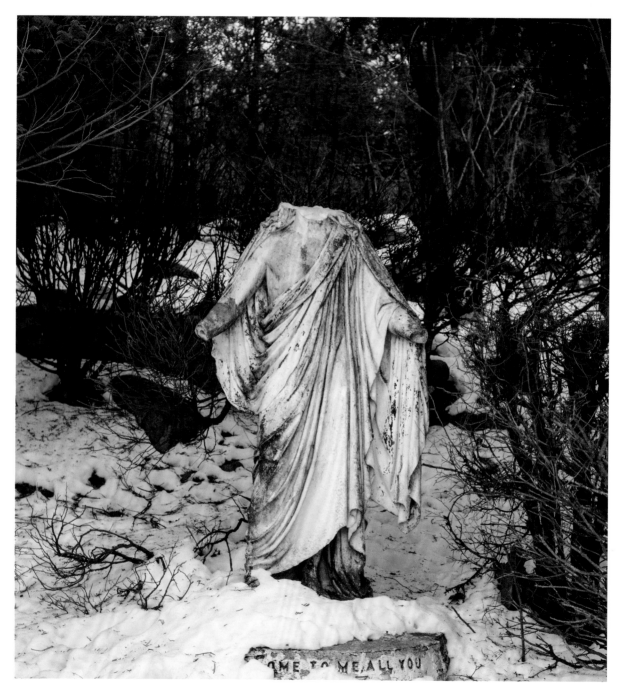

Find Momo Coast to Coast

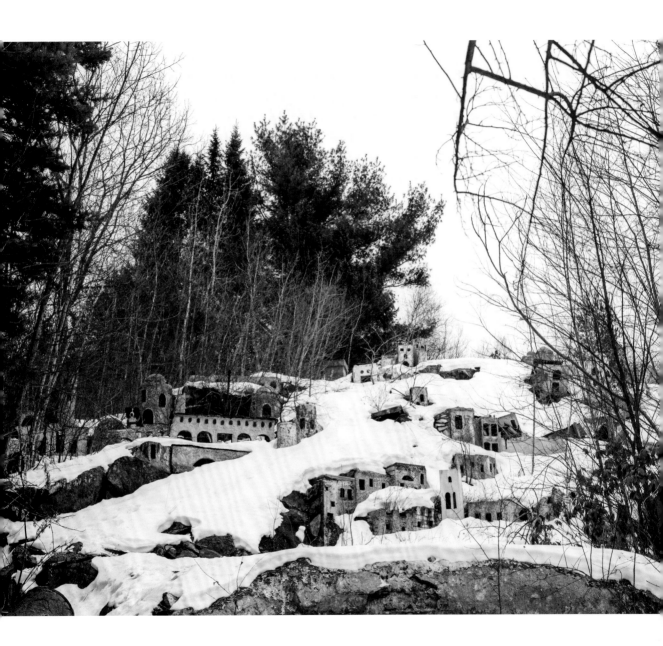

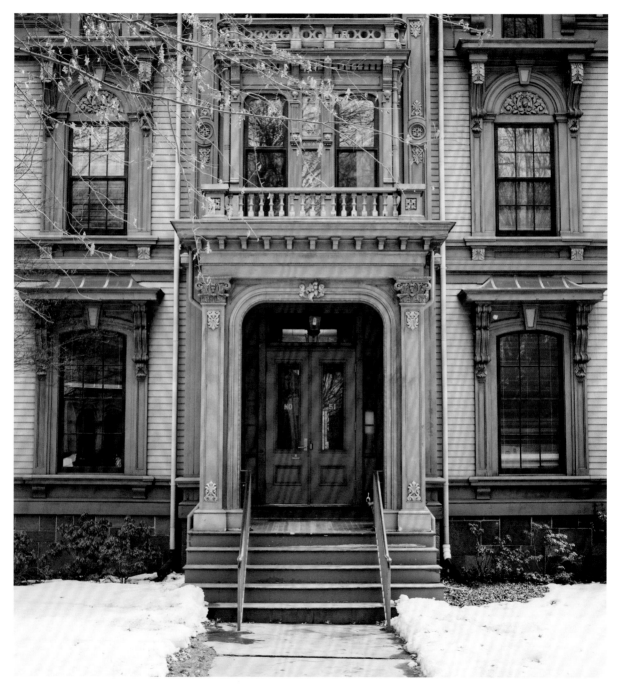

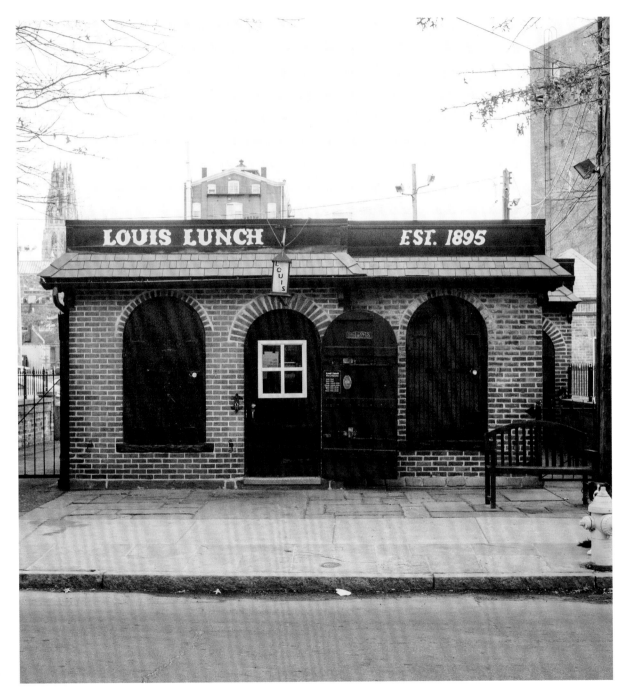

New England

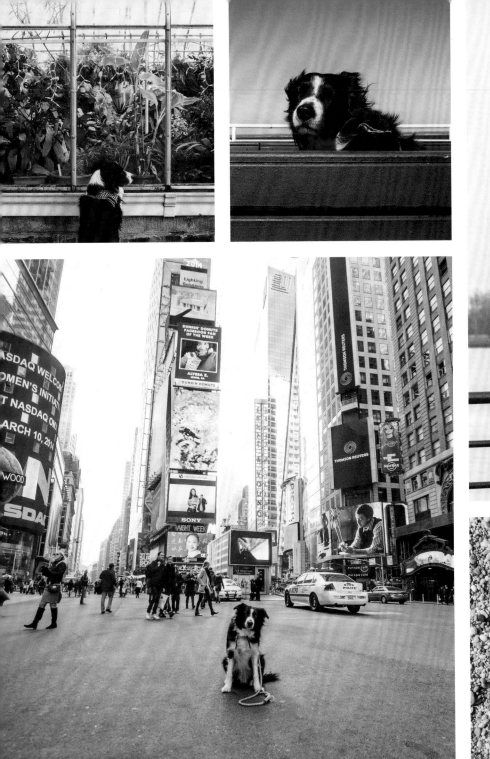
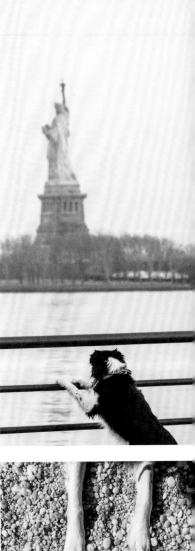

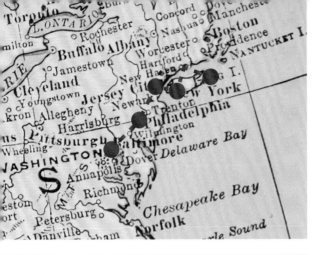

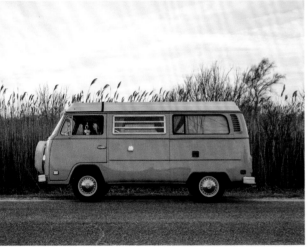

MID-ATLANTIC

We had two choices for traveling to New York City: pass overland or take a ferry.

The ferry is better for meeting people. On almost every ferry ride, Momo and I meet someone with lots of stories. On this trip, that person was a guy named Dave. He told me all about the Long Island area, about the island owned by the inventor of the Segway PT, about the Plum Island super-secure medical testing facility, about New London Ledge Lighthouse, and much more.

Momo gets pretty freaked out on ferries—crashing waves, fog horns, and flapping flags. But he finds peaceful moments amid the chaos, when he can feel the cool wind in his fur.

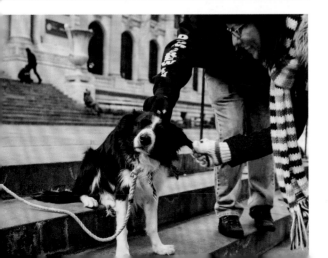

(*opposite, clockwise from top left*) Admiring the foliage at the Edgerton Park Conservancy, New Haven, CT; riding the ferry to Long Island, NY; a glimpse of Ellis Island from Liberty State Park, Jersey City, NJ; our route; the van in Montauk; making friends at the New York Public Library; on the beach on Long Island, NY; Times Square in New York City.

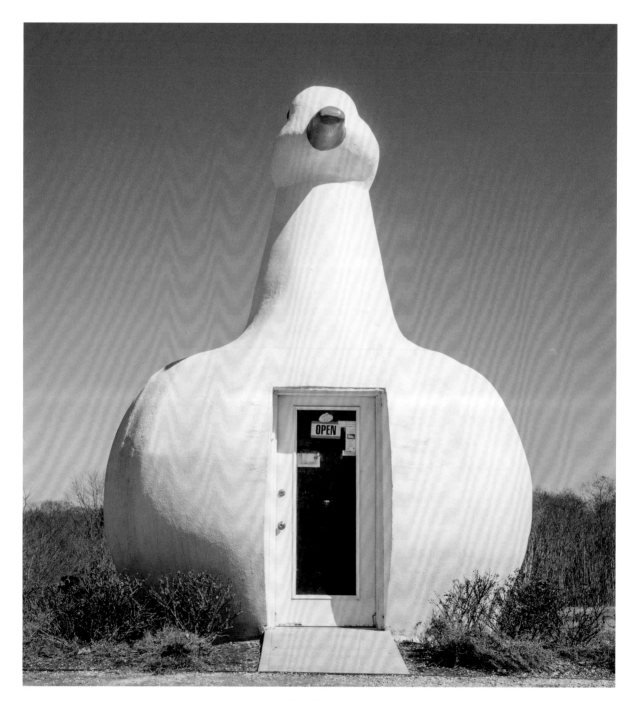

Find Momo Coast to Coast

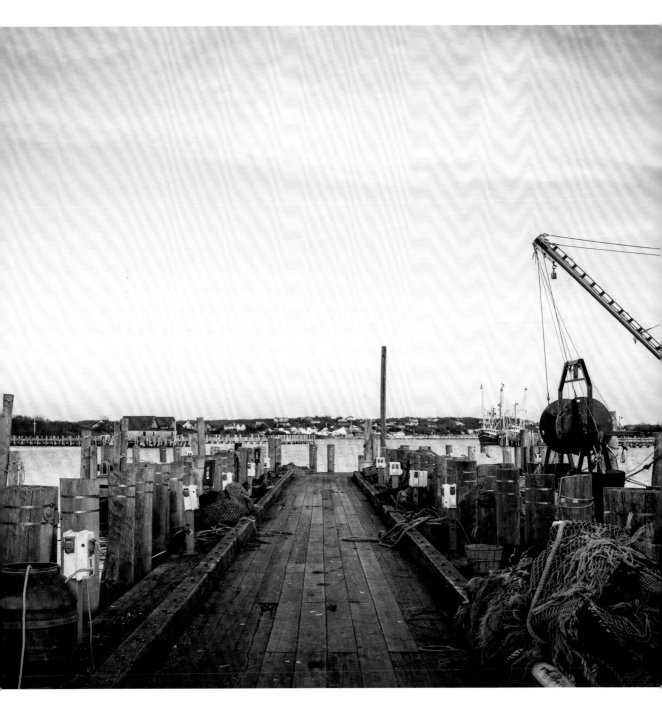

Mid-Atlantic

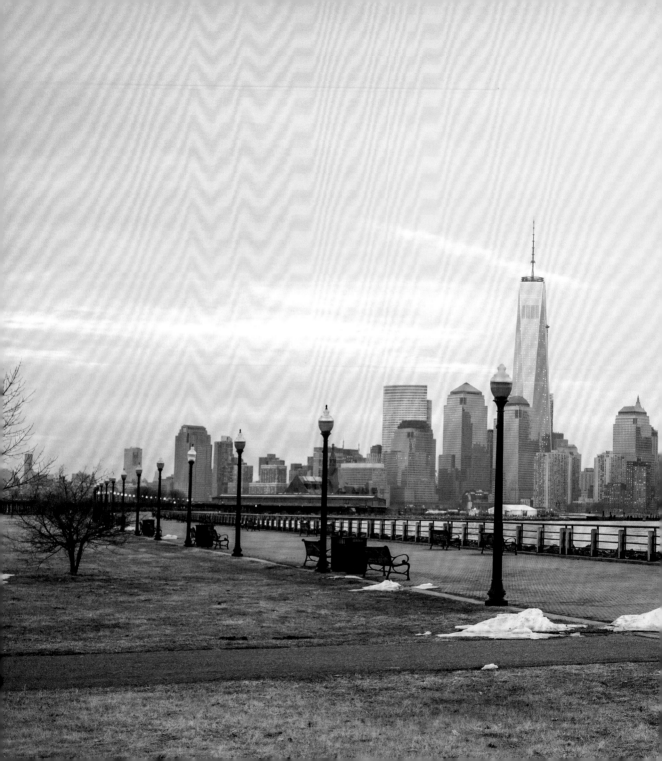

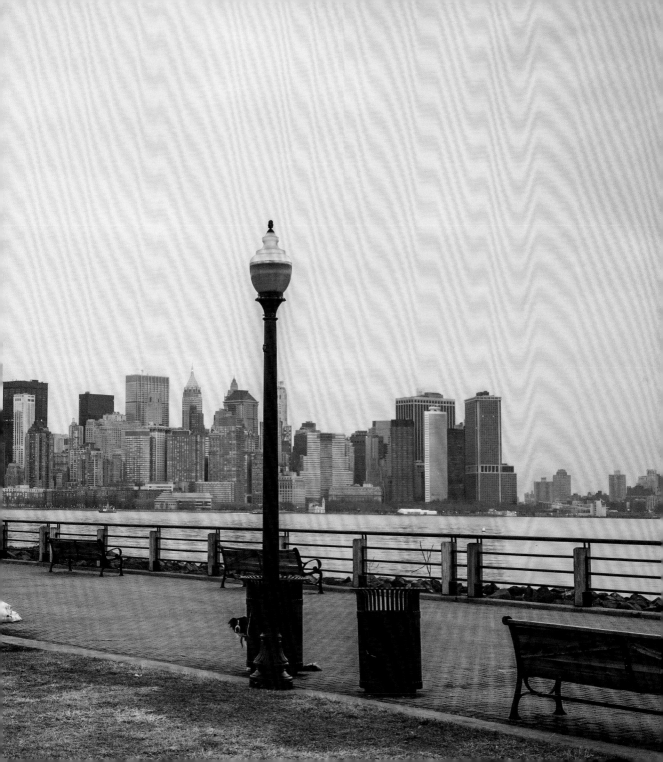

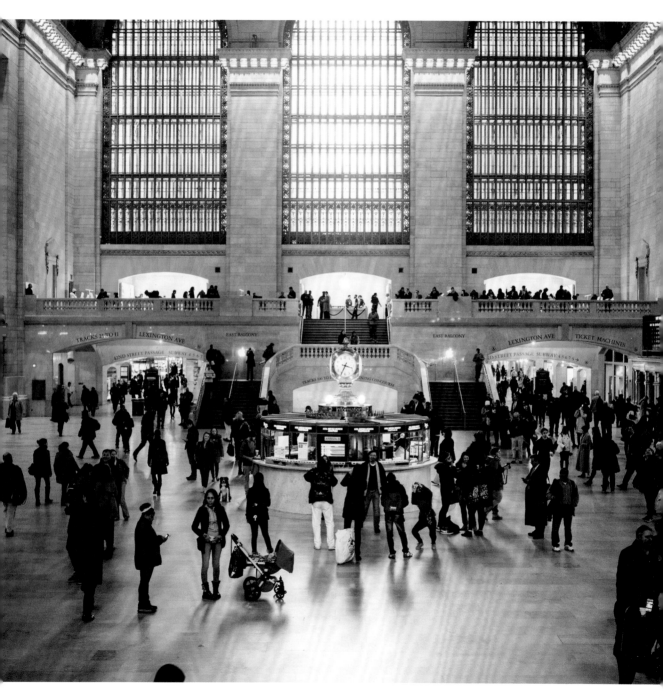

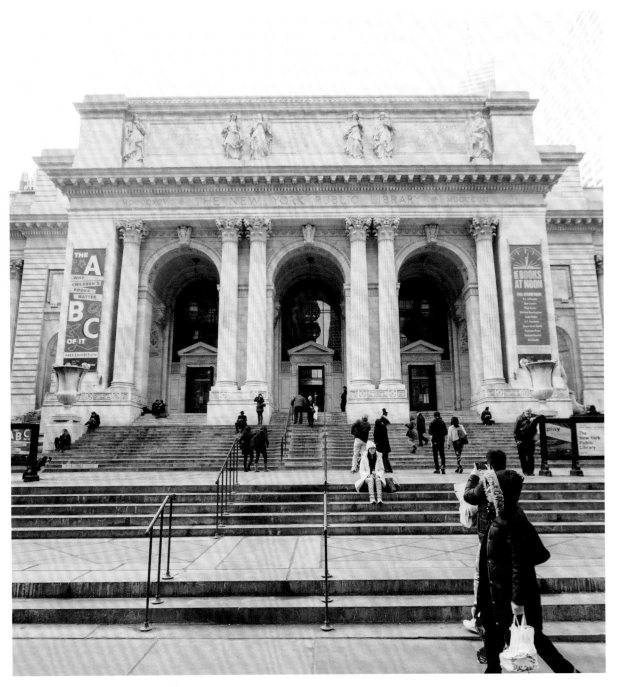

Mid-Atlantic

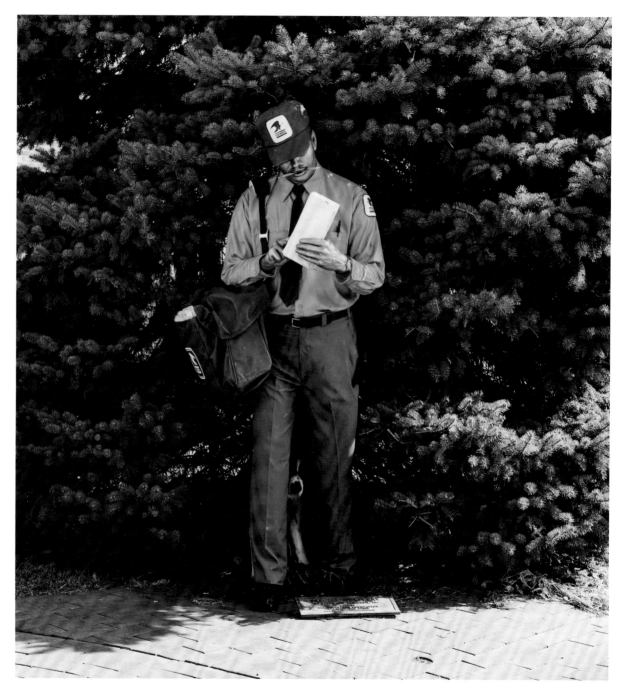

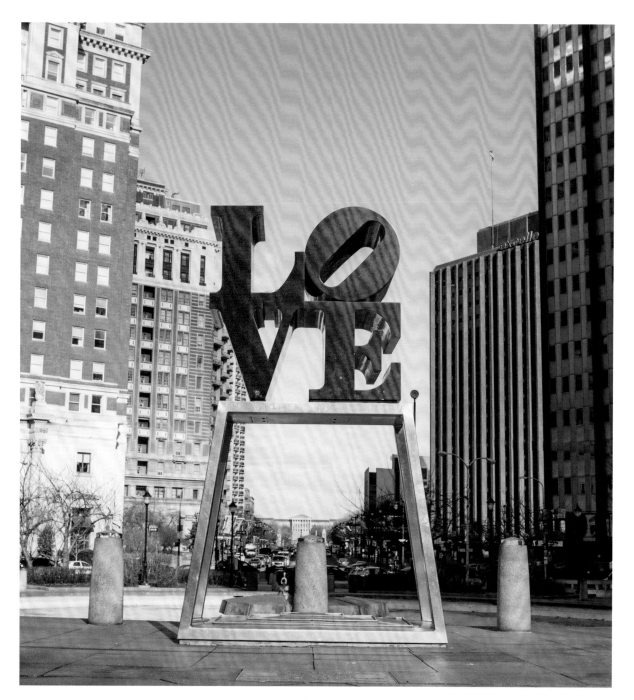

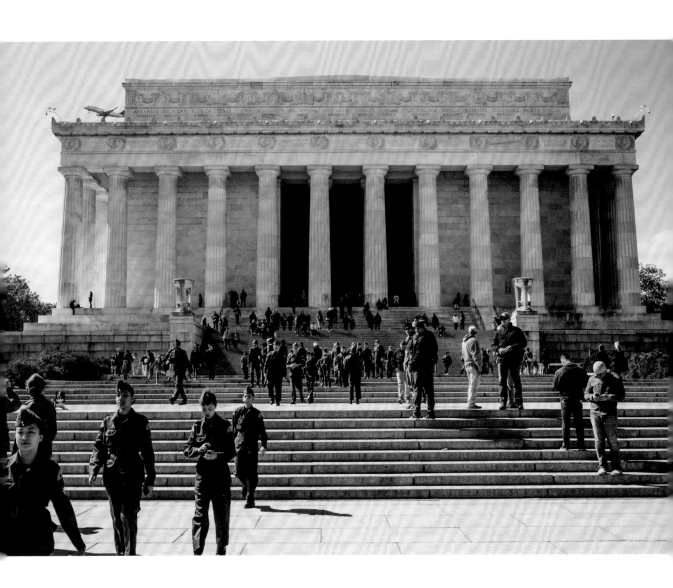

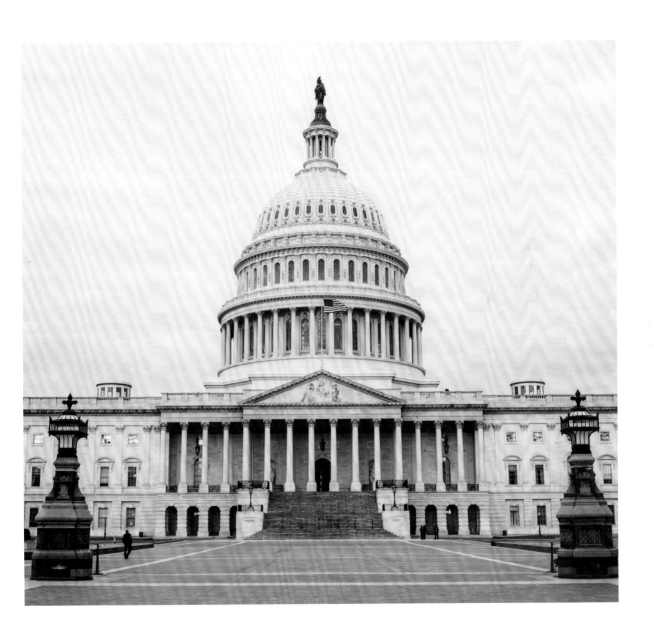

Mid-Atlantic

• 35 •

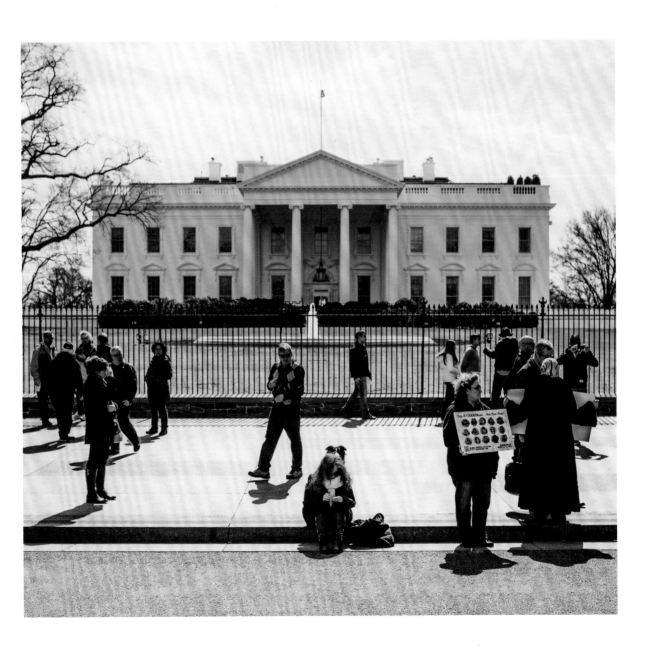

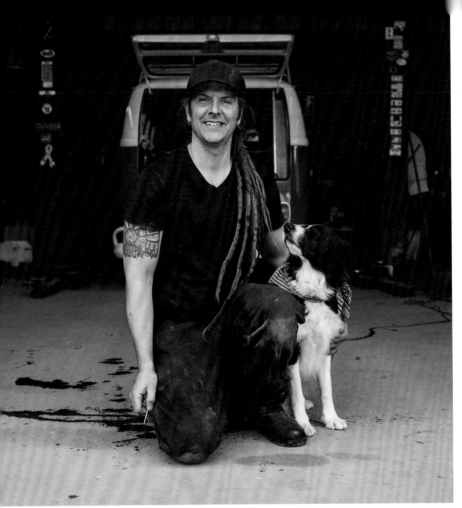

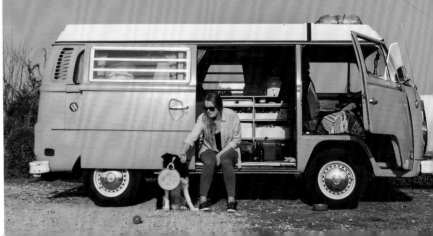

NOT A CANCER ON THE
LEAVE ROOM FOR NATUR
LEAVE ROOM FOR NA

NORTH CAROLINA, GEORGIA, AND ALABAMA

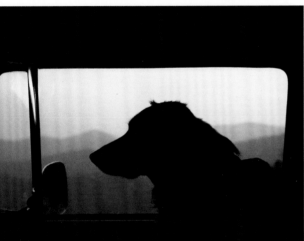

If I could bring along someone to take care of my van, it would be Chris, owner of Asheville Vee Dub in North Carolina (*opposite, top left*). What a place. Chris knows air-cooled VWs better than anyone I've met and approaches them with a grin. He swapped out the master brake cylinder and checked the brakes, and he let me change the oil and replace the air flow meter (which had been plaguing me for over a year).

Chris also showed us his green and white 1966 VW "splitty" before we hit the road for brighter and warmer climates. Our yellow van was sounding better than ever.

(opposite, clockwise from top left) Chris at Asheville Vee Dub, Asheville, NC; two stops in Atlanta, GA; among the Blue Ridge Mountains near Asheville; our route; our friend Annie with Momo; taking a snooze in the van; at the Georgia Guidestones, Elbert County, GA.

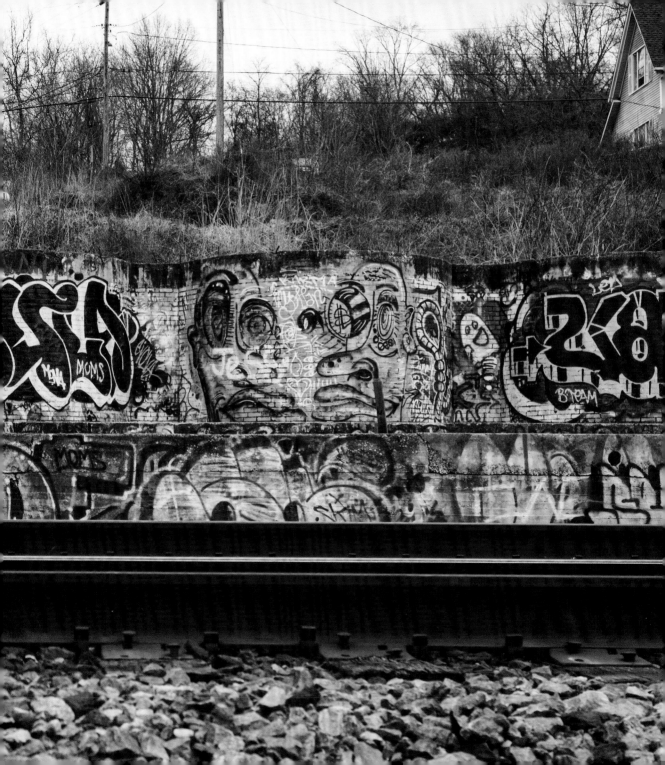

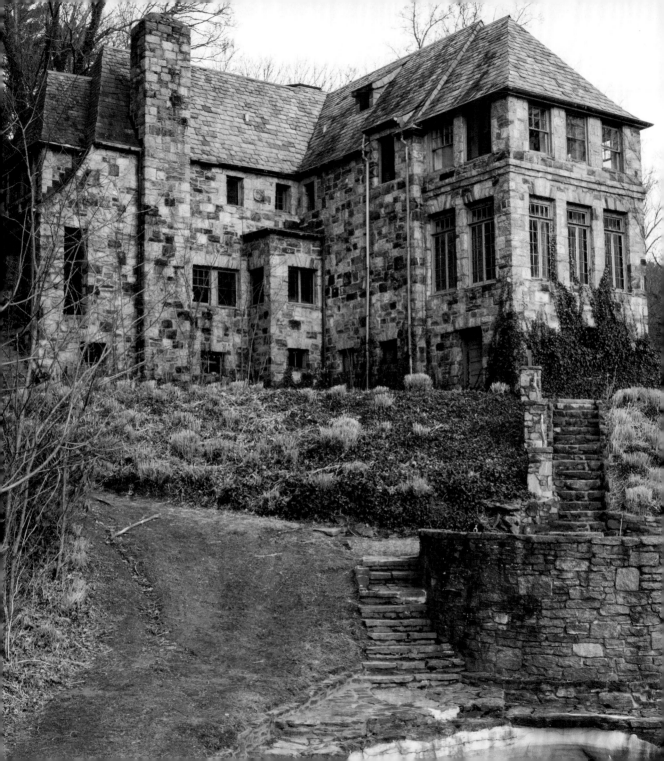

North Carolina, Georgia, and Alabama

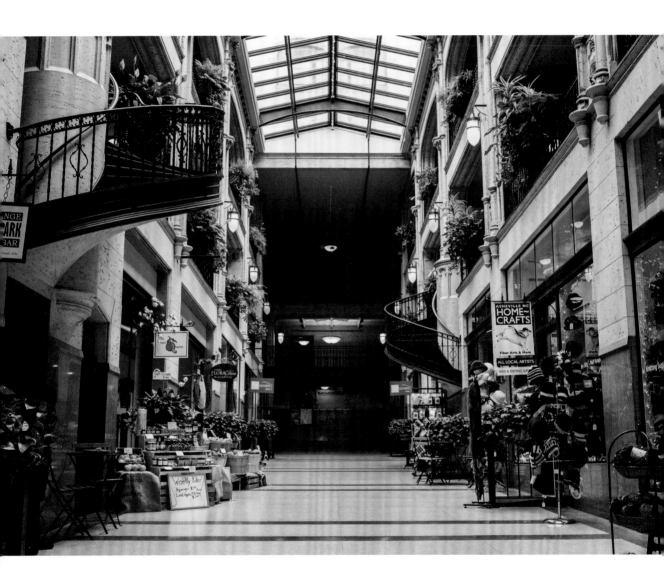

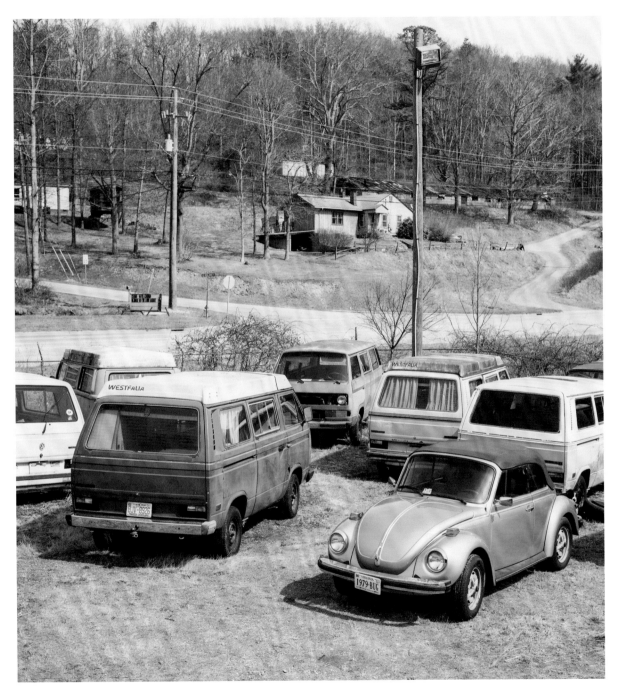

North Carolina, Georgia, and Alabama

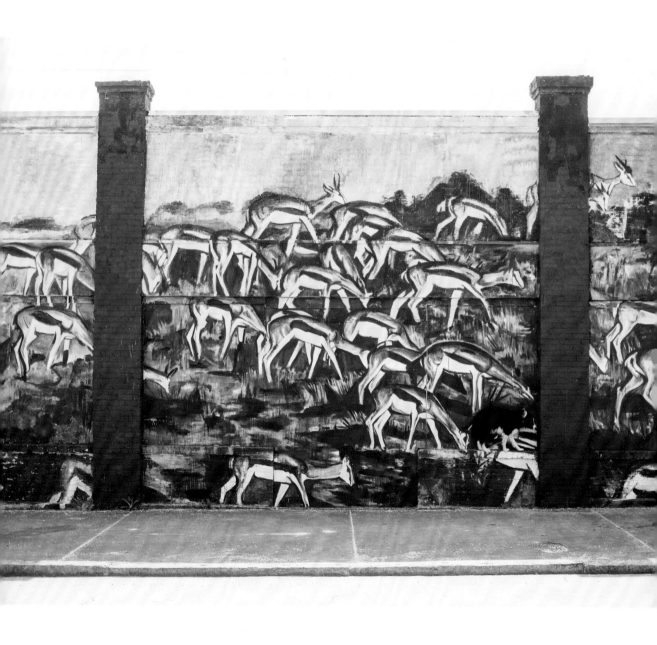

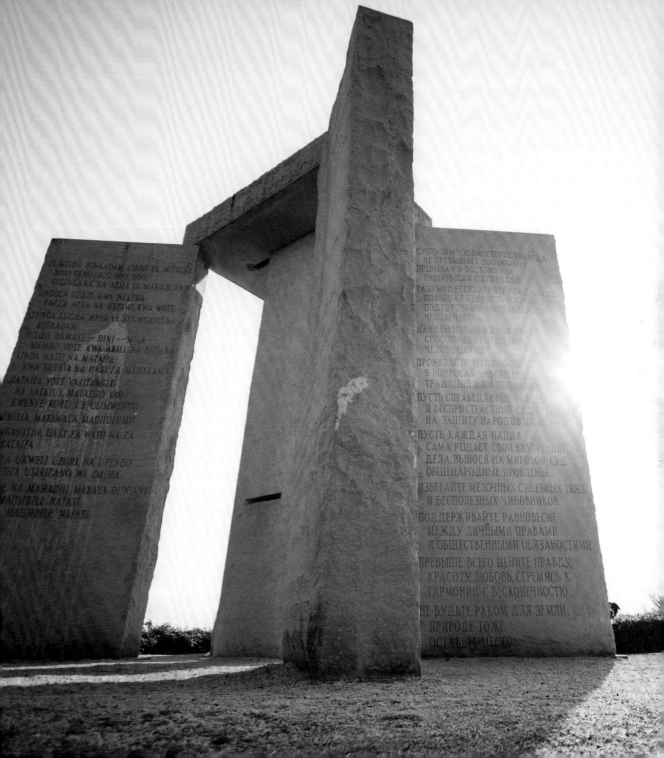

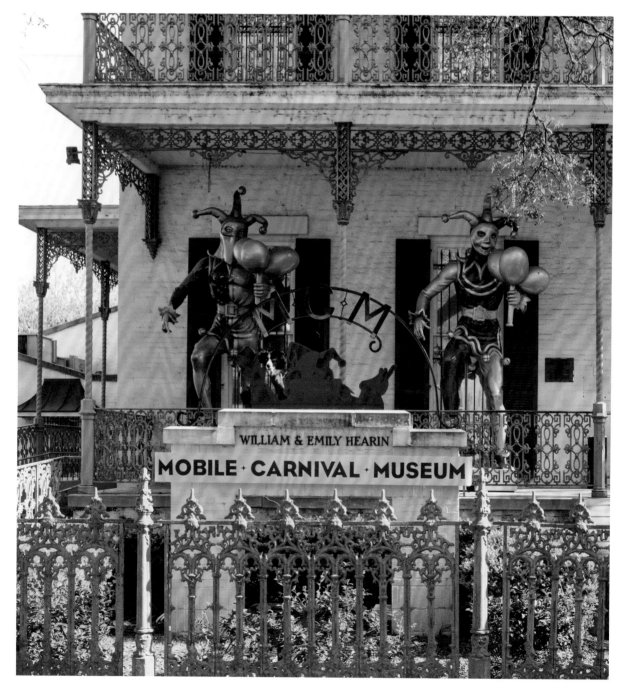

WILLIAM & EMILY HEARIN
MOBILE · CARNIVAL · MUSEUM

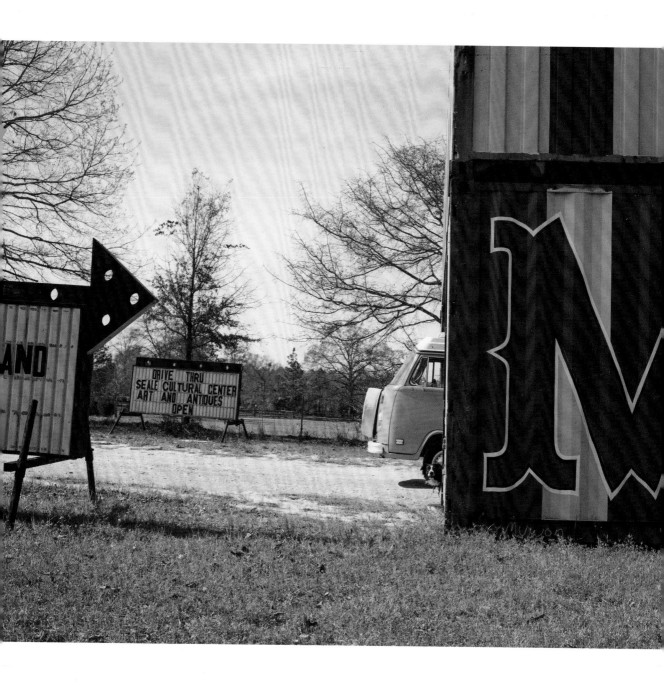

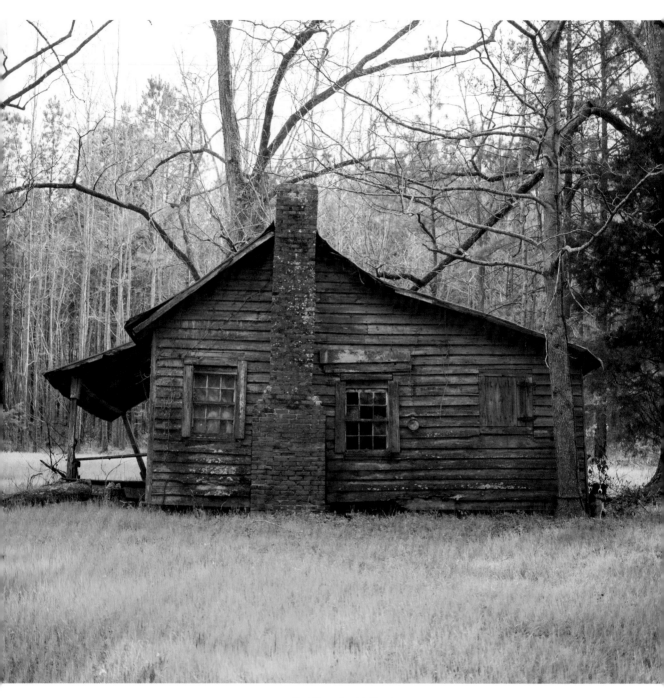

North Carolina, Georgia, and Alabama

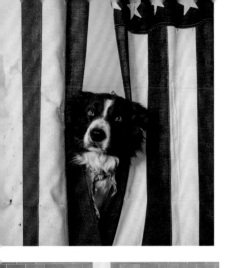

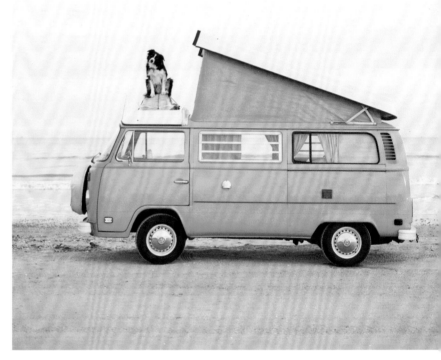

LOUISIANA, TEXAS, AND OKLAHOMA

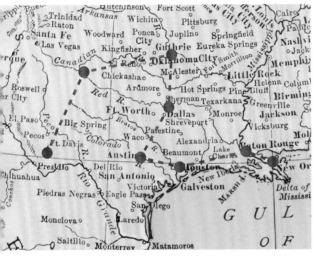

Among all the lessons Momo has taught me, this one has changed me the most: *Explore*. When he was a puppy, we grew tired of taking the same short walks and started venturing around nearby forests and lakes. I'm forever grateful to Momo for that, because these weren't excursions I would have taken without him. That lesson has become a lifestyle—Momo and I are always seeking the "other" route. The greatest reward is the unexpected one.

And we were definitely in for a few unexpected rewards on this leg of our trip.... We'd soon learn that the American South is a weird and wonderful place.

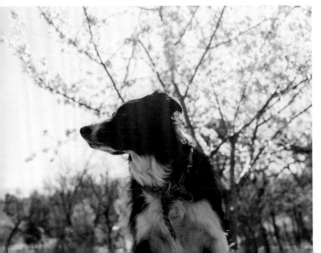

(*opposite, clockwise from top left*) At the communal kitchen at El Cosmico campground, Marfa, TX; on a hurricane-damaged abandoned camping beach in Texas; our friend Emily passes Momo a note in a former schoolhouse near New Sweden, TX; our route; outside the Philbrook Museum of Art, Tulsa, OK; Prada Marfa, Marfa, TX; New Orleans, LA; Adickes SculpturWorx Studio, Houston, TX.

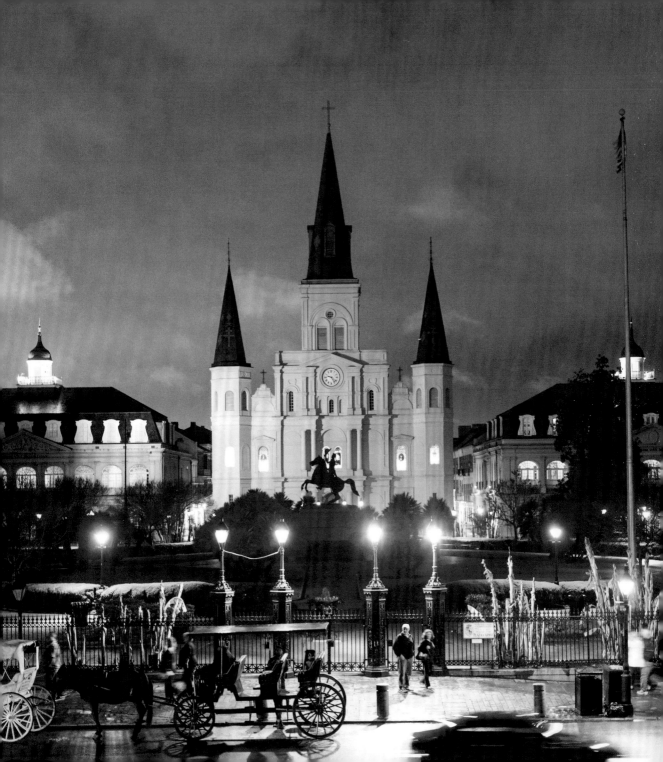

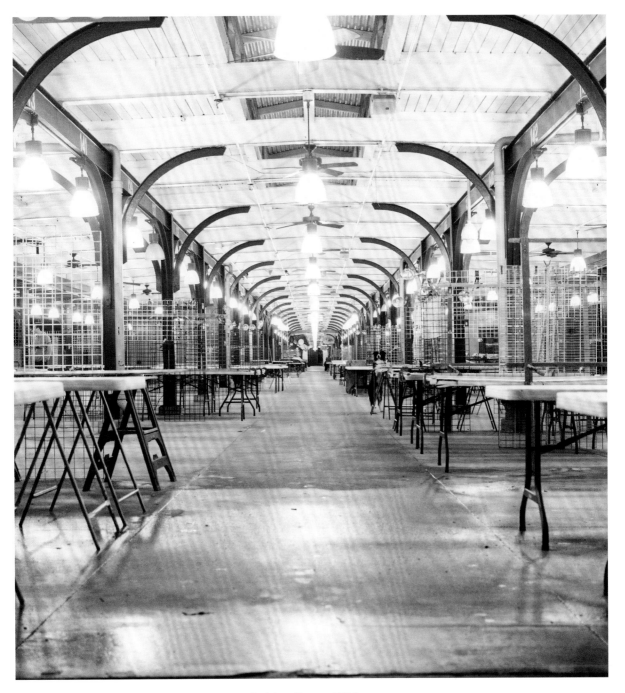

Louisiana, Texas, and Oklahoma

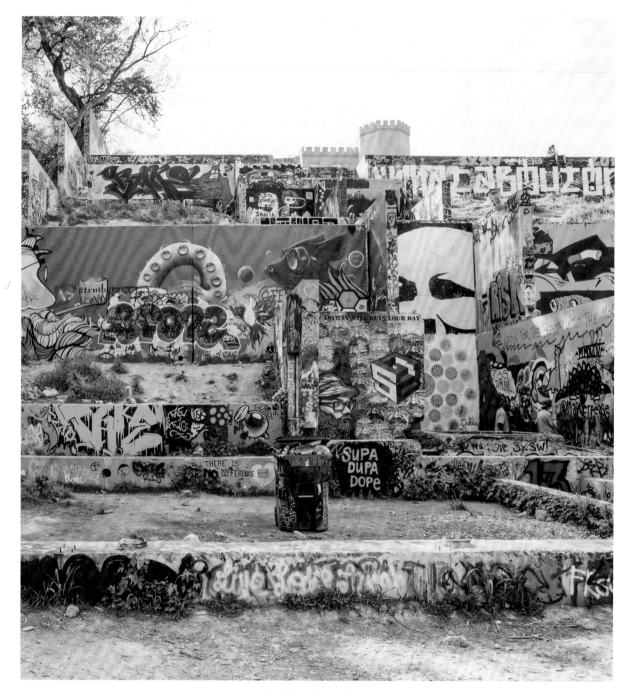

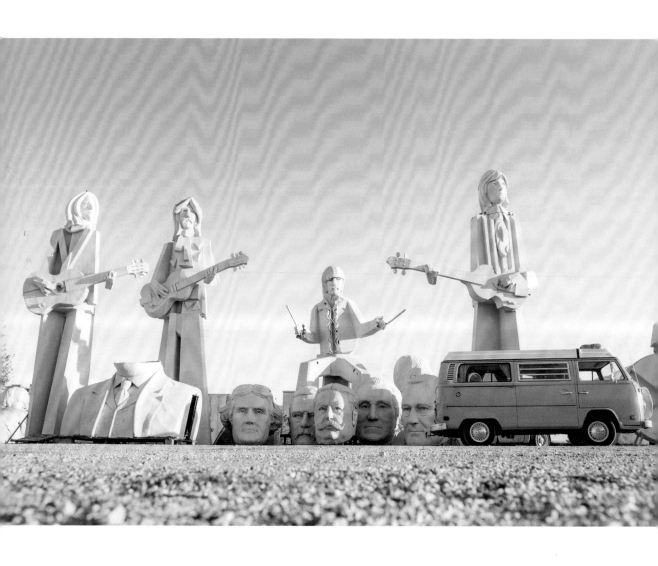

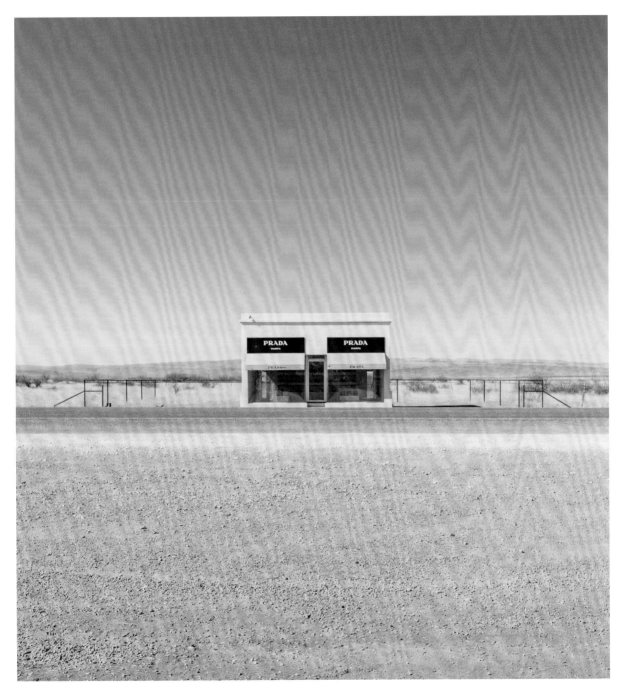

Louisiana, Texas, and Oklahoma

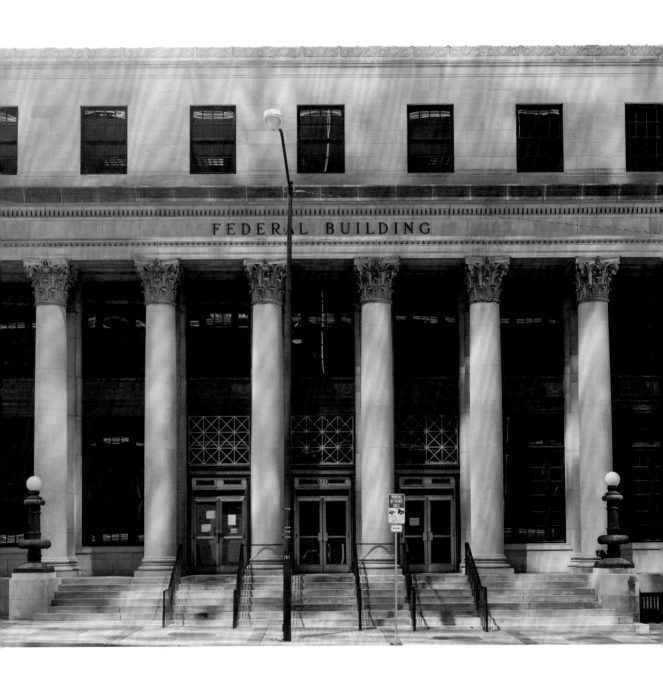

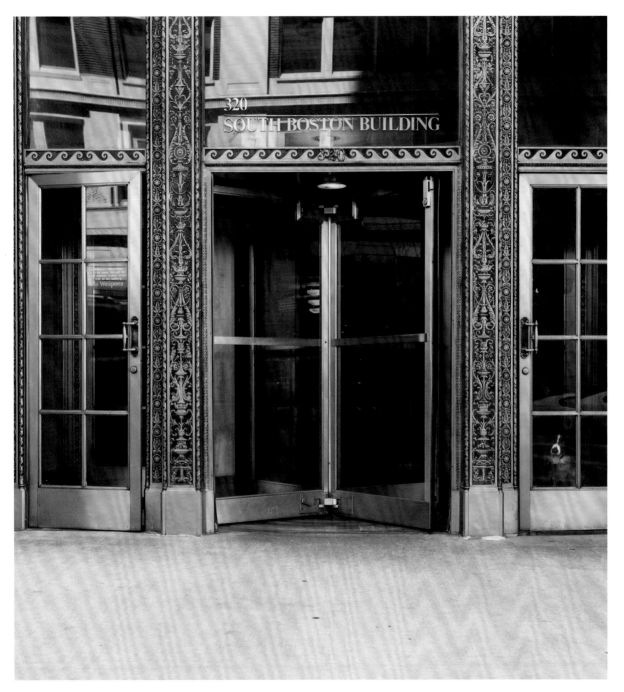

Louisiana, Texas, and Oklahoma

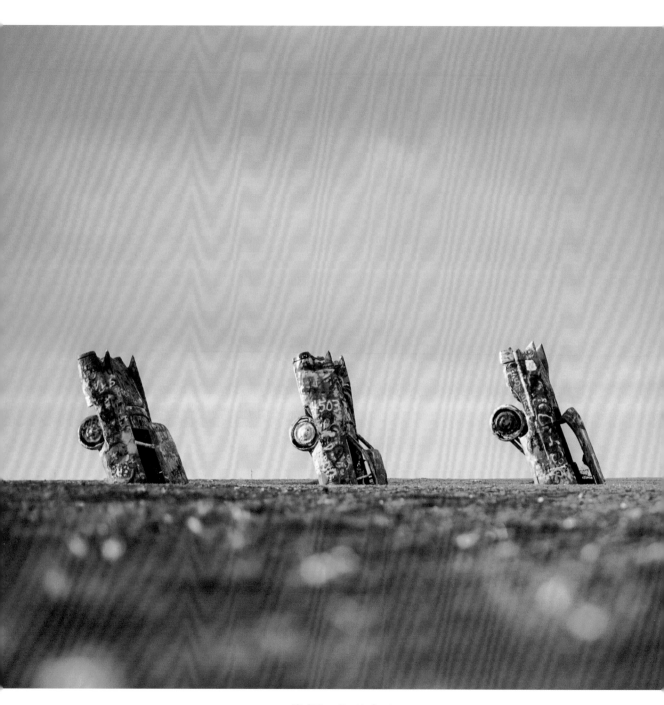

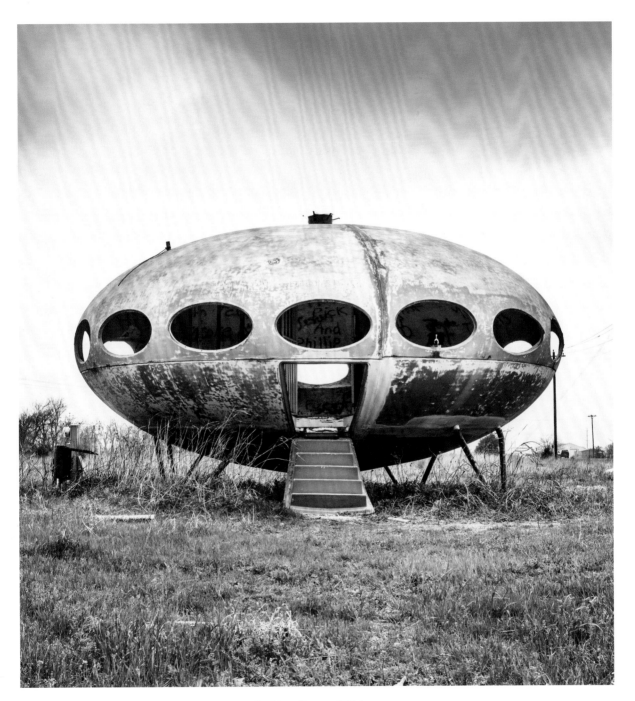

Louisiana, Texas, and Oklahoma

Louisiana, Texas, and Oklahoma

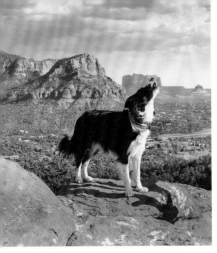
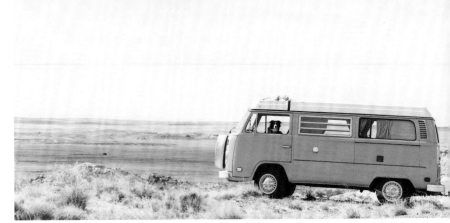

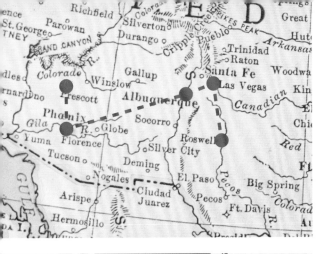

THE SOUTHWEST

For some time I have dreamed of visiting White Sands National Monument in New Mexico. The state certainly lived up to its nickname, the Land of Enchantment. As Momo and I traveled through the San Andres Mountains, I was concerned that we wouldn't find many hiding spots in a desert of stark white sand. But we found a few and explored until the sun set.

The next morning Momo and I met some of our campsite neighbors: Martha and Danny (*this page, center*) left behind home and work twelve years ago to take a one-year trip in their RV. They've been on the road ever since. Their smiles were contagious, and I couldn't help but suspect their happiness was from life on the road.

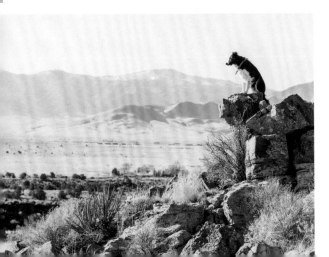

(*opposite, clockwise from top left*) Momo channels his inner wolf amid the desert beauty of Sedona, AZ; Petrified Forest National Park, AZ; our route; our new friends Martha and Danny; campsite near Carrizozo, NM; Momo and our friend Zach behind the Neon Museum in Las Vegas, NV; just after Zach's girlfriend, Jade, kissed Momo on the snout; in southern New Mexico near the Organ Mountains.

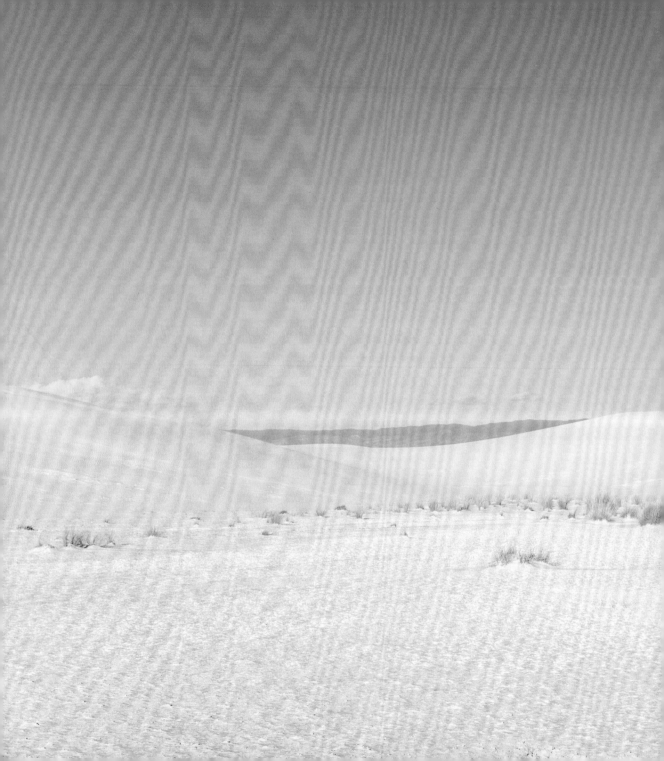

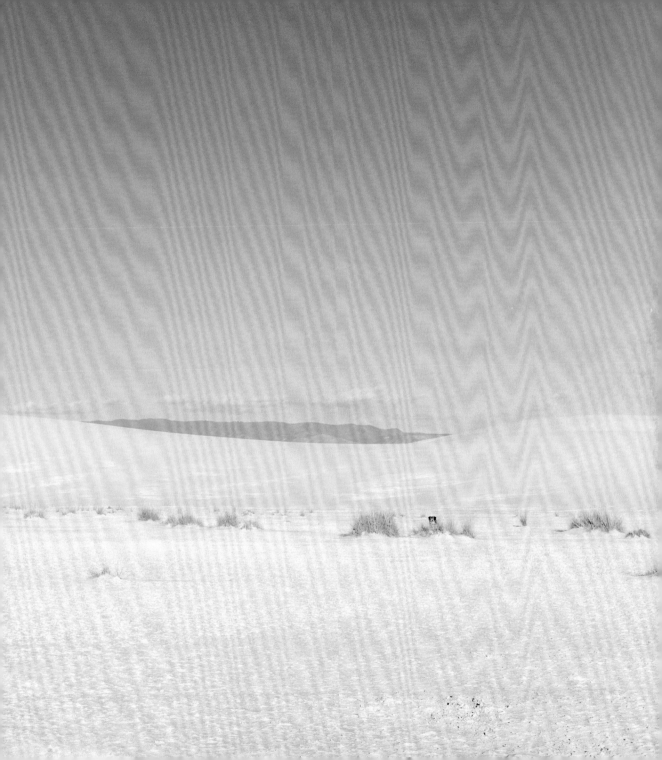

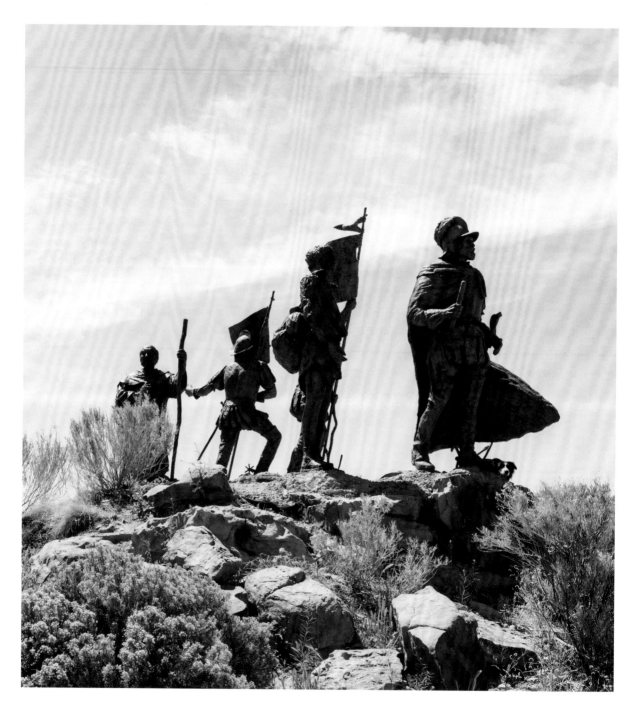

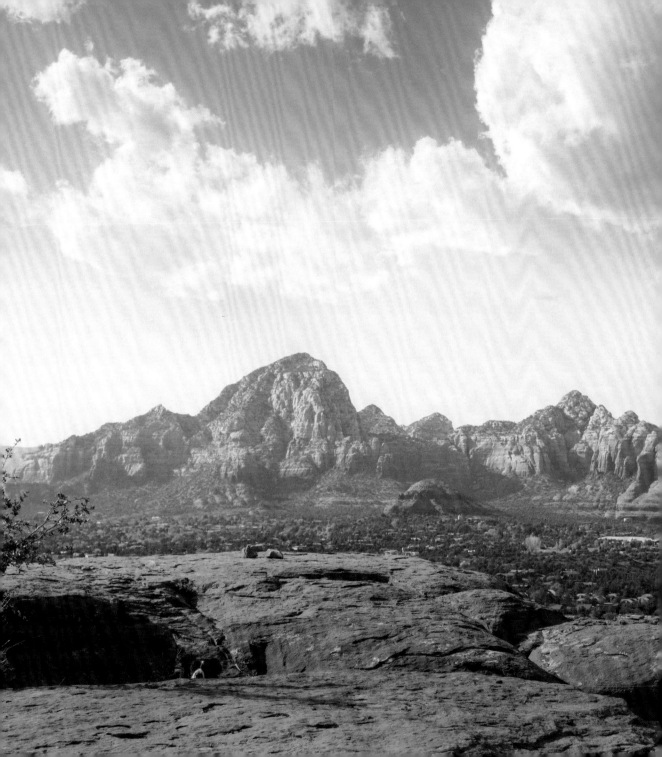

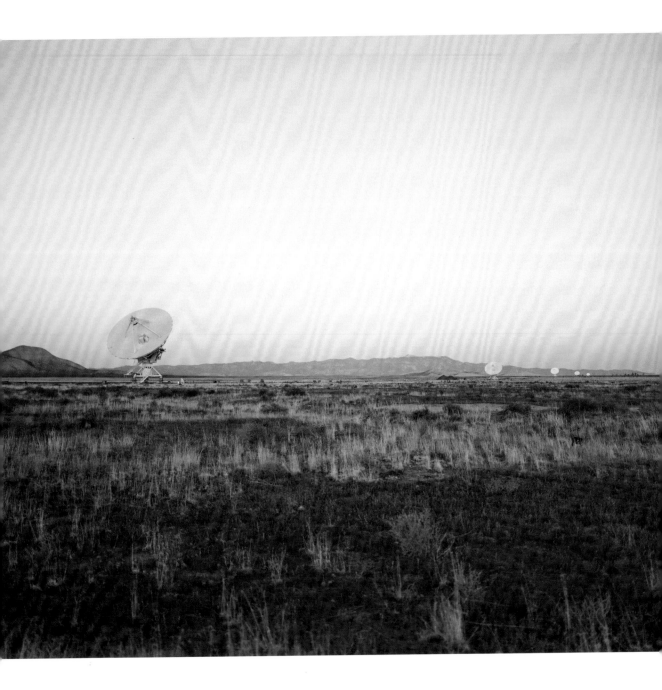

Find Momo Coast to Coast

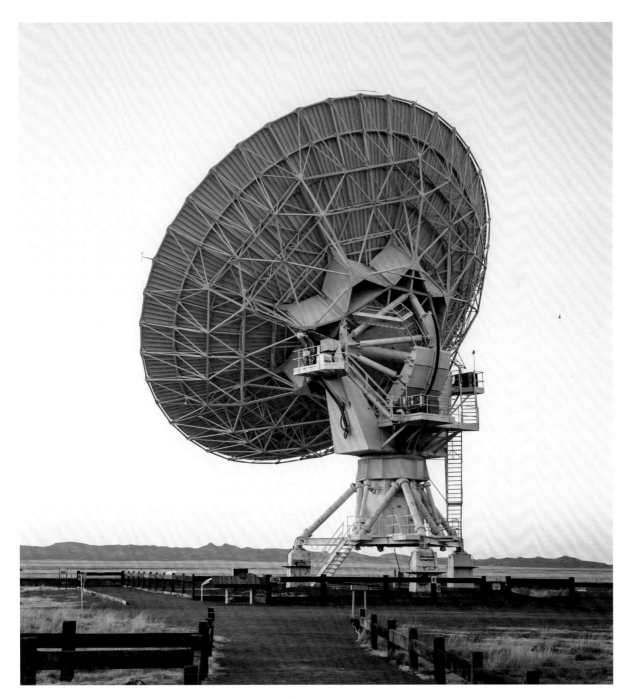

The Southwest

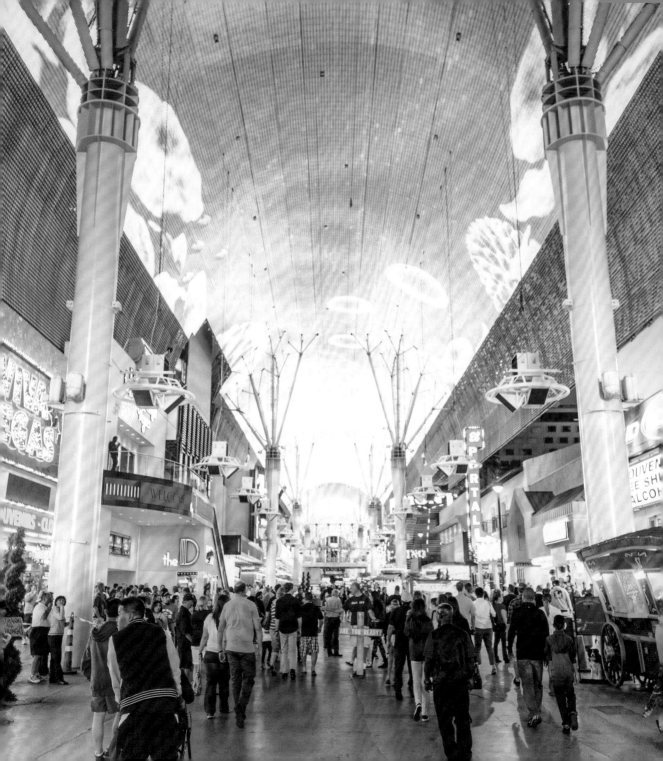

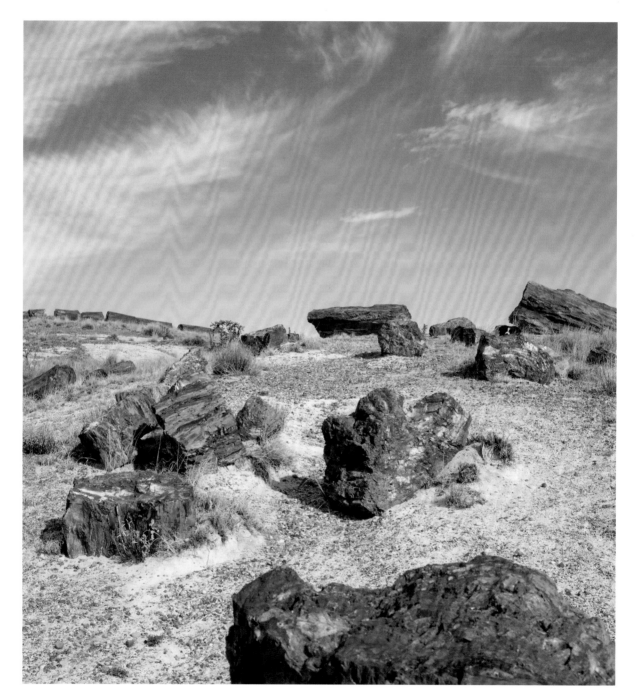

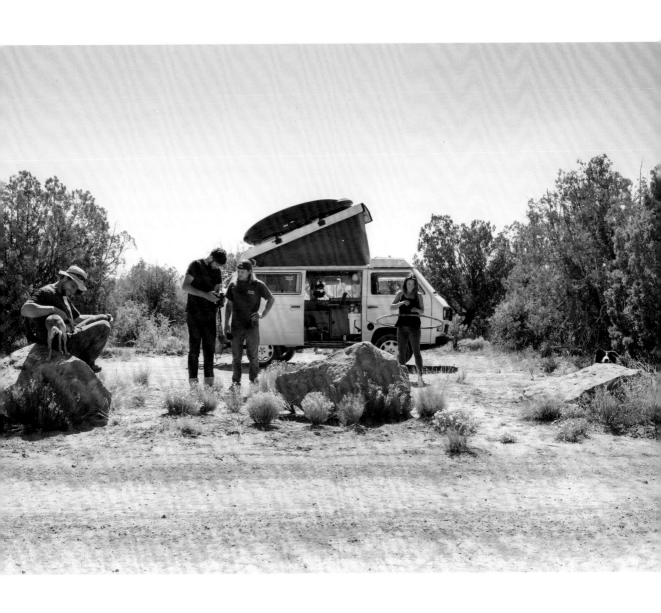

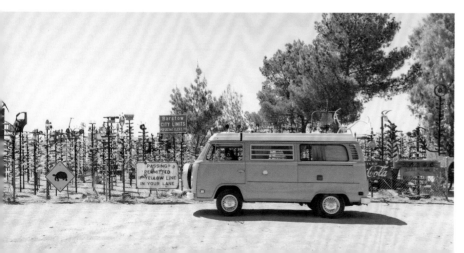

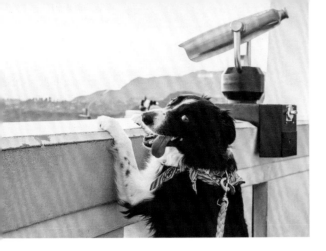

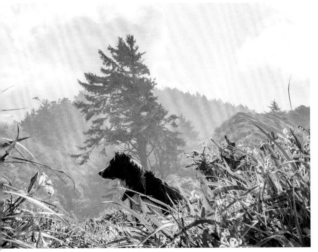

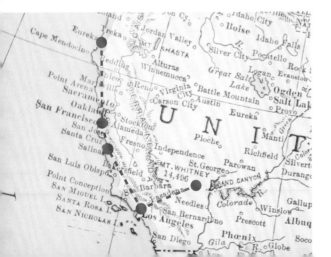

CALIFORNIA

I've always had a soft spot for the West Coast. There's something restorative about the sun setting in the mist of the sea and the lush, towering mountains. The remote and rural areas contain startling attractions and incredible people.

Long treks with Momo always remind me to be in the here and now. I'll find my mind drifting to the end of the trail, or the upcoming steep slope, or the van where there's food, shade, water, and music. But then I look at Momo, and he immediately looks back at me. He's smiling, as if reminding me to be content with where we are. I take a breath and enjoy the moment.

(*opposite, clockwise from top left*) Damnation Creek Trail near Crescent City; our friend Sanne and Momo under a foggy Golden Gate Bridge in San Francisco; Momo looking out from Griffith Observatory, Los Angeles; Damnation Creek Trail; our route; head tilting in downtown Los Angeles; at Elmer Long's Bottle Tree Ranch in Oro Grande; on the steep streets of San Francisco.

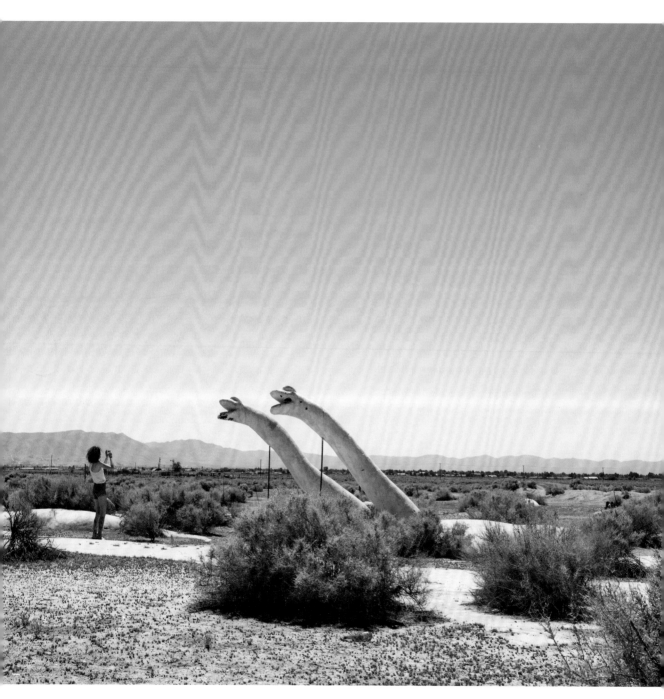

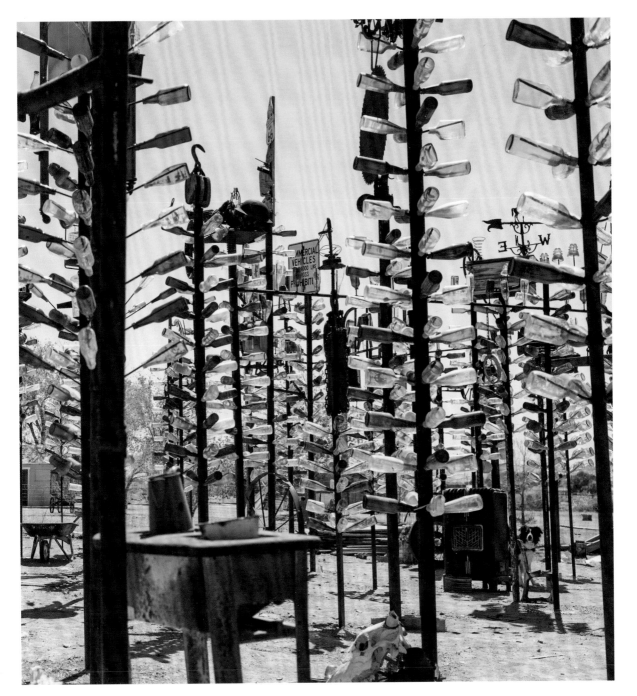

California

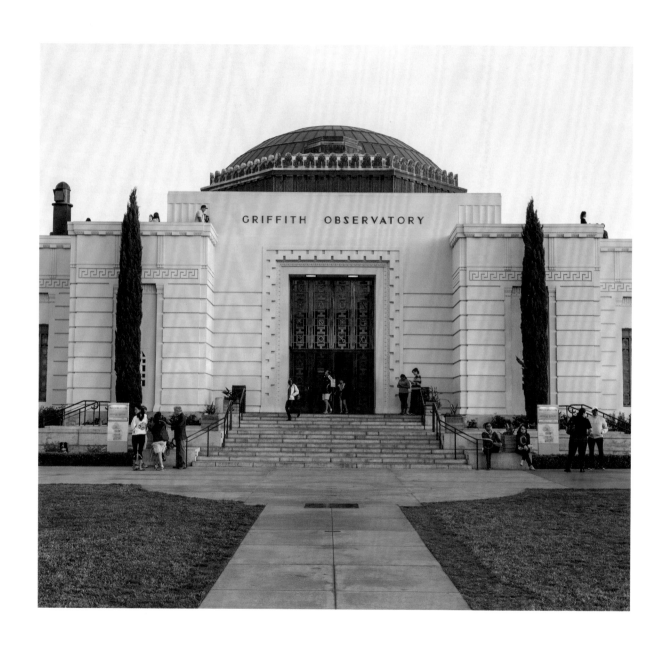

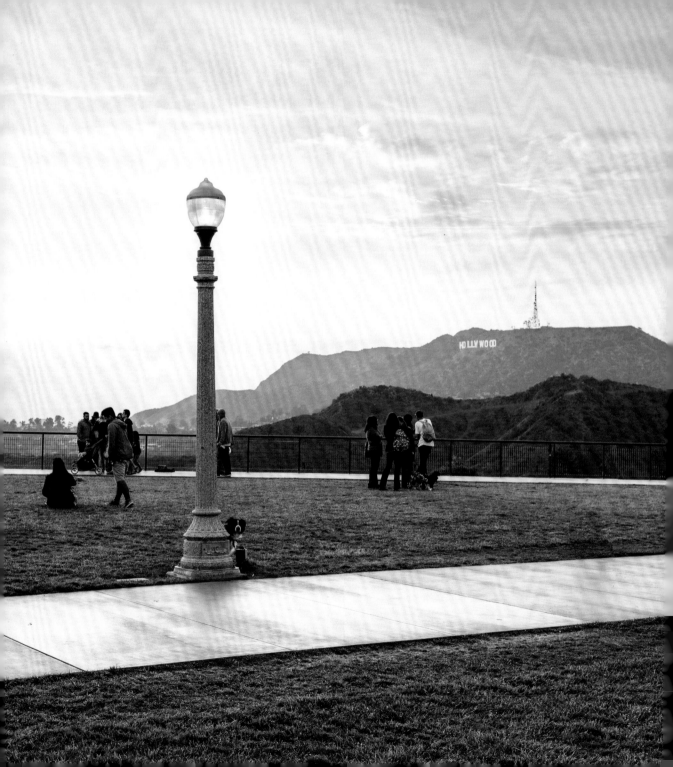

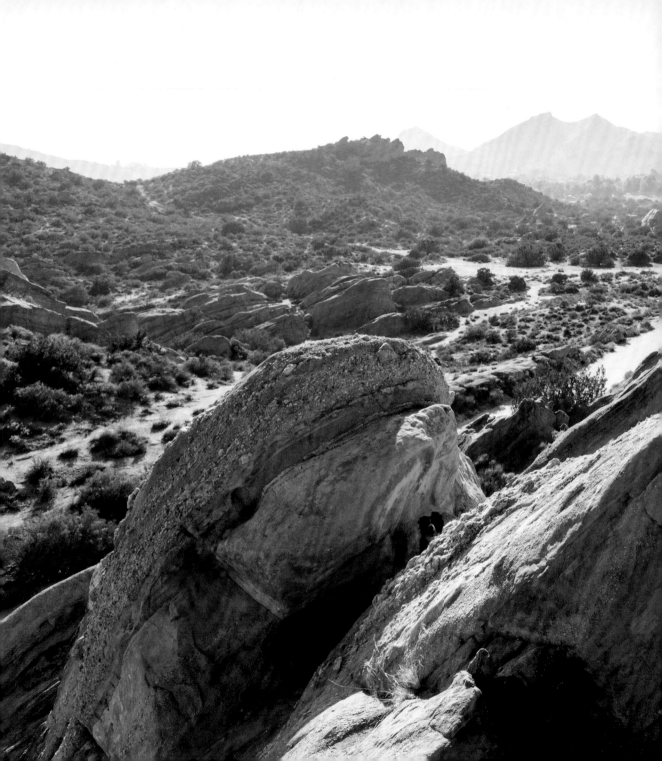

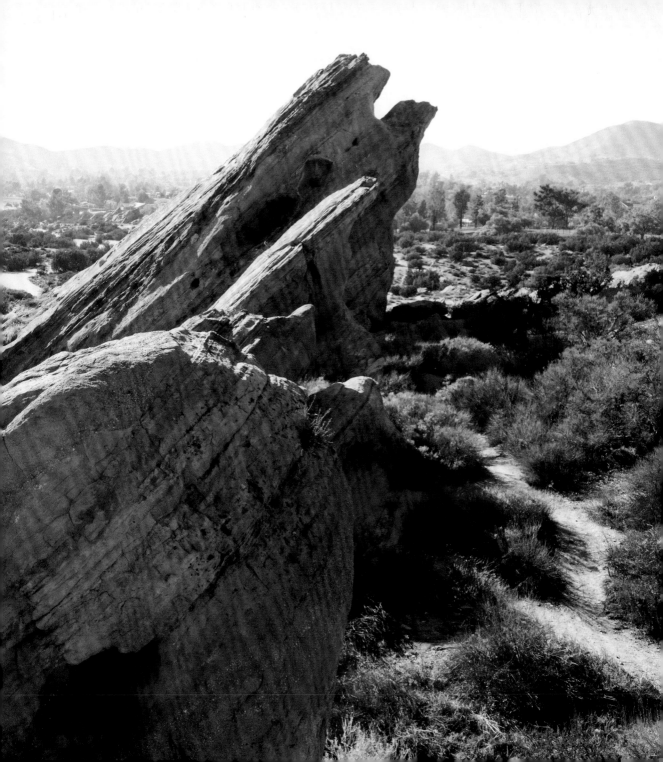

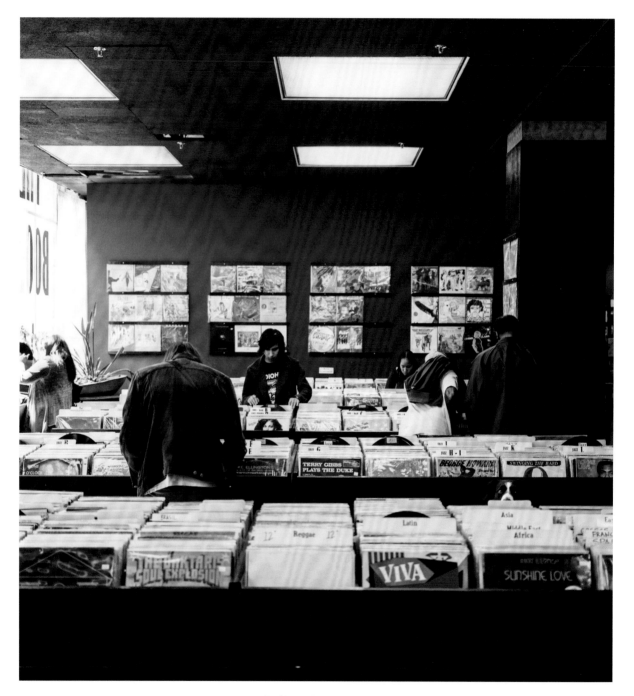

California

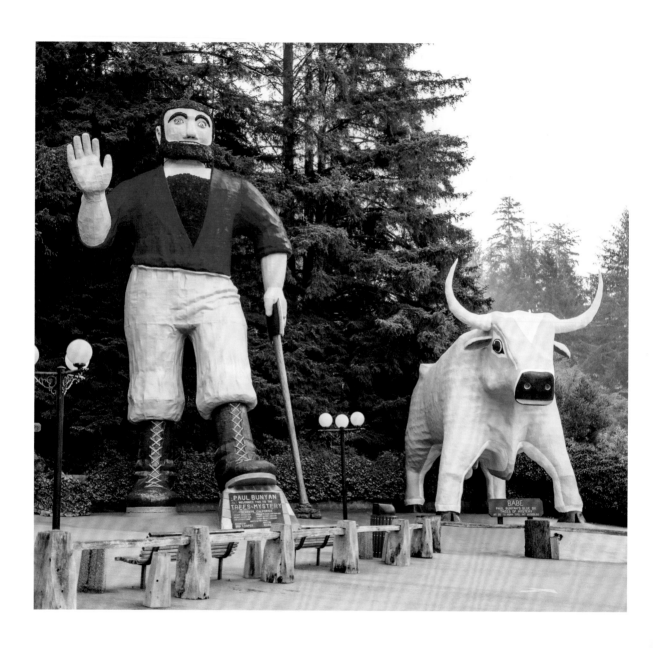

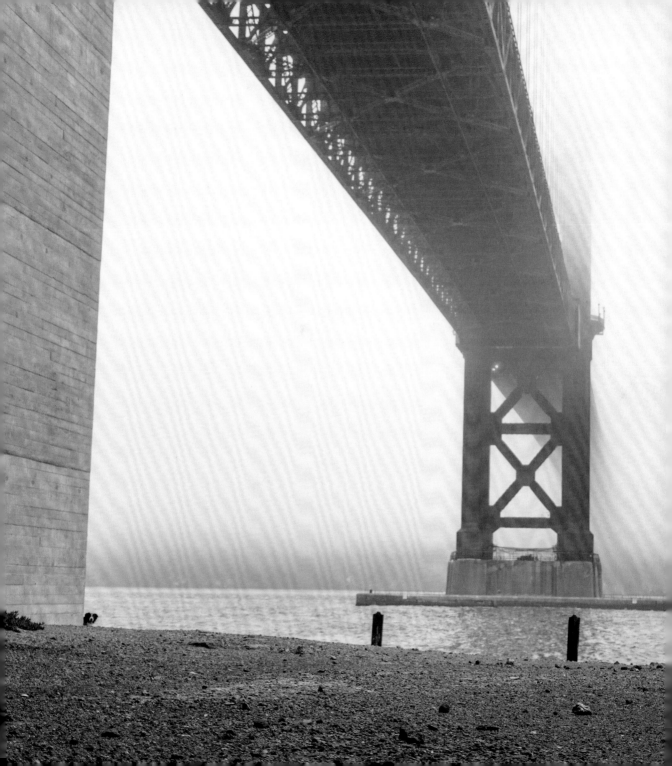

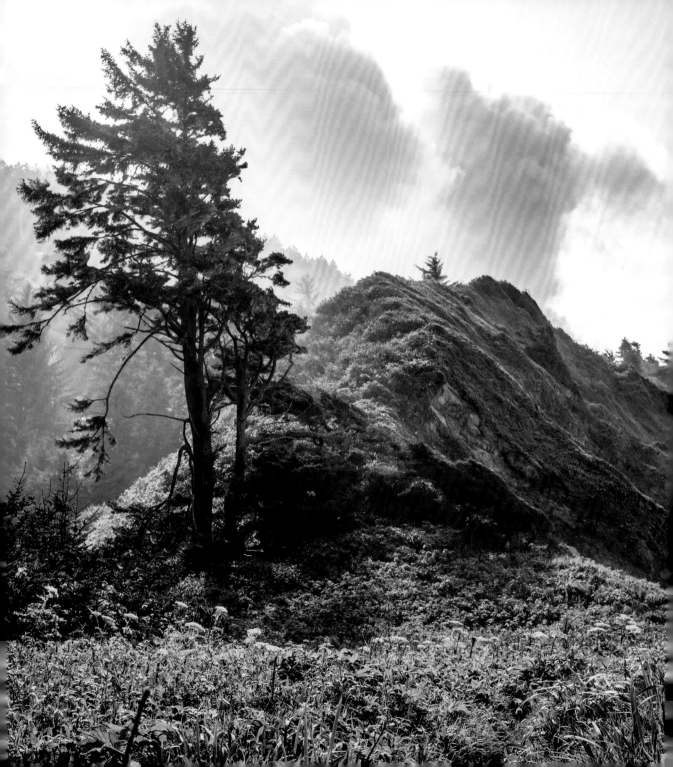

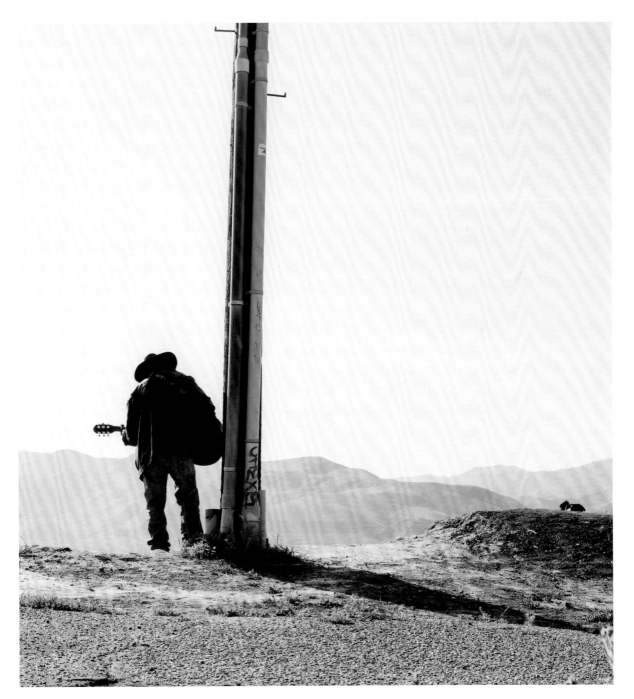

California

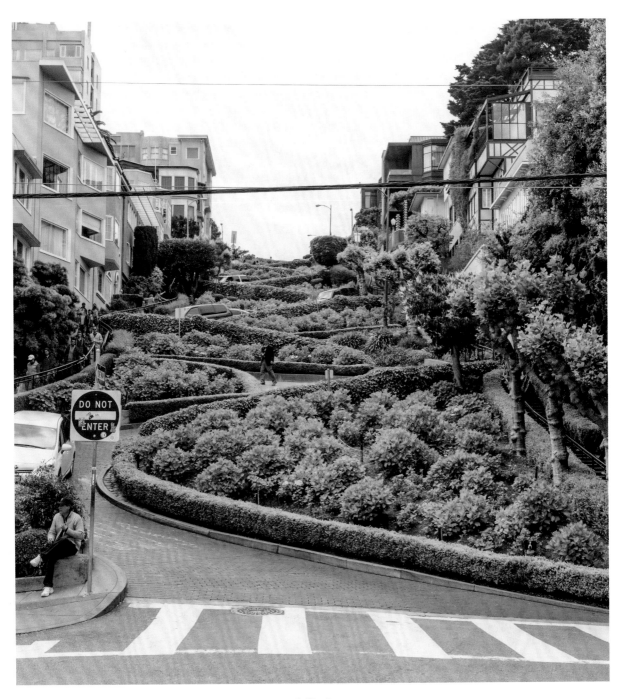

California

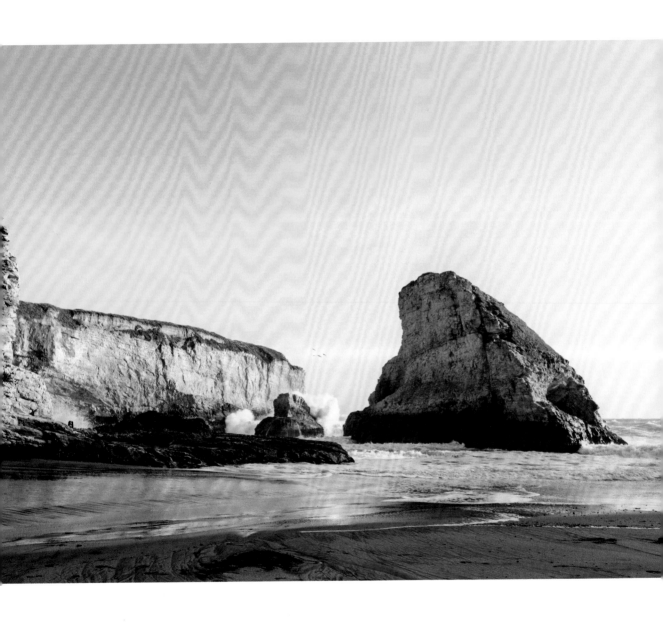

California

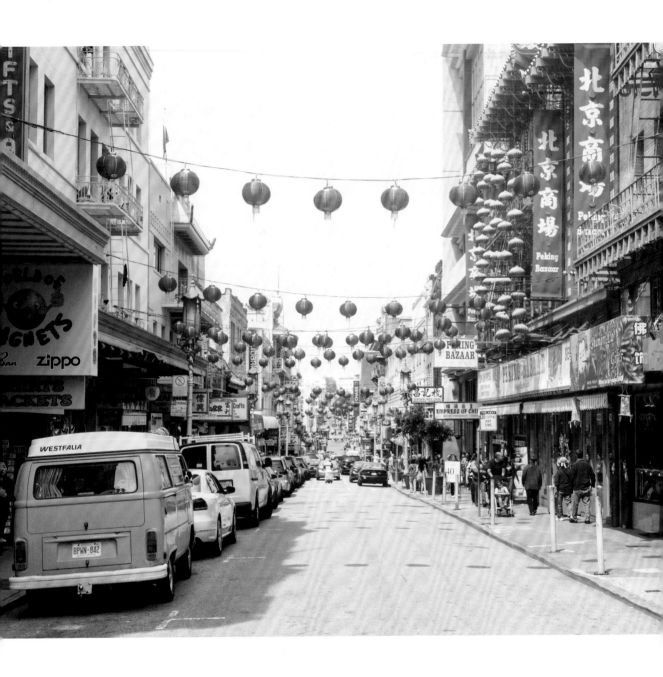

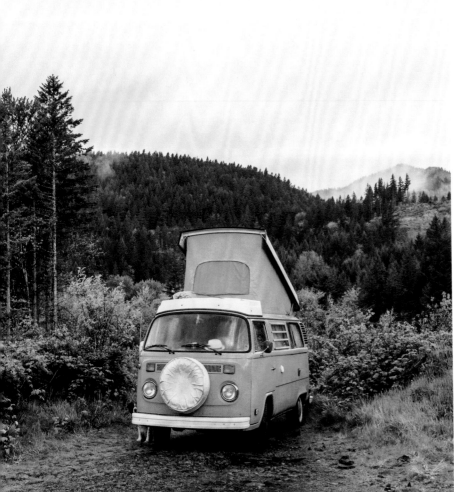

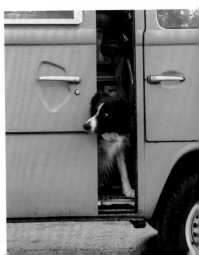

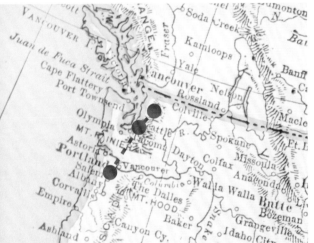

THE NORTHWEST

I'd somehow forgotten how lush the Pacific Northwest is. Driving into Oregon, I was excited about the good coffee, but we were welcomed by so much more. Waterfalls and winding roads that take your breath away. Thick green foliage that covers every inch of the earth. And a quality in the air that feels pure and cleansing. The people we met and communities we visited were especially dog friendly.

(opposite, clockwise from top left) Gas Works Park, Seattle, WA; the view of Seattle from Gas Works Park; near Bellingham, WA; our route; taking cover in Seattle, WA; Momo waiting for the ferry from Port Angeles, WA, to Canada; our camping spot near Carson, WA; driftwood somewhere in the Pacific Northwest.

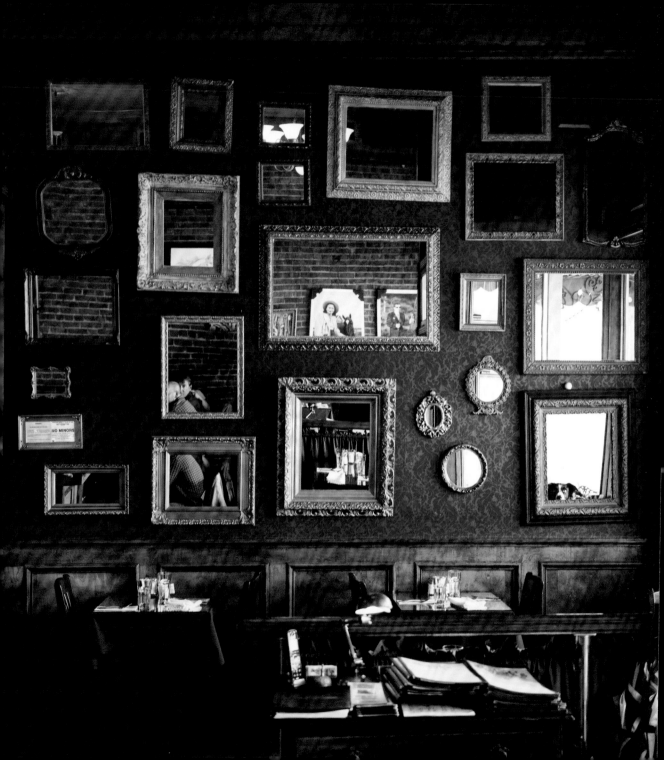

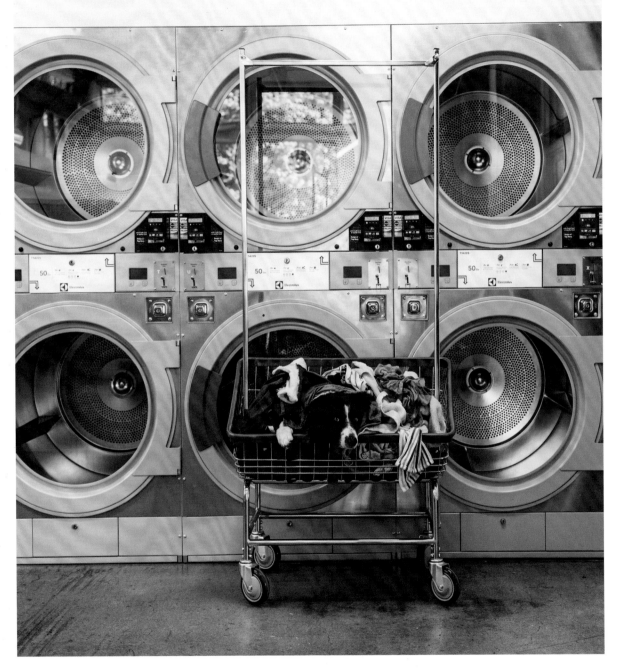

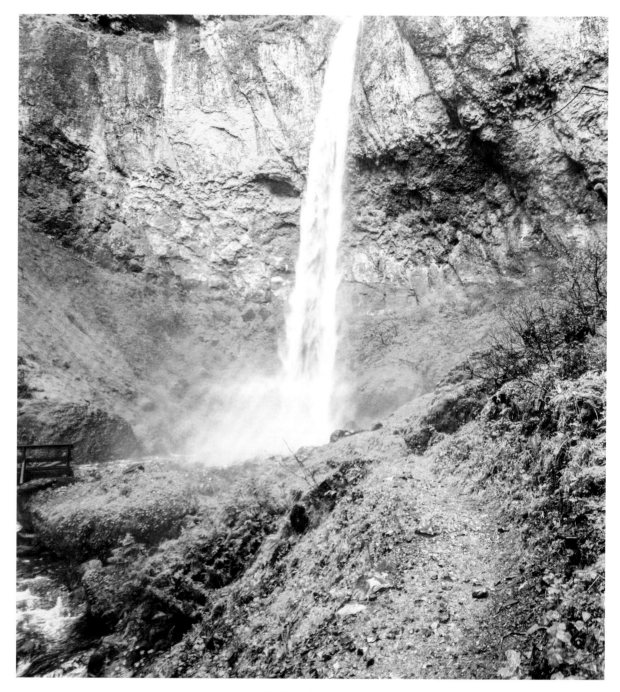

Find Momo Coast to Coast

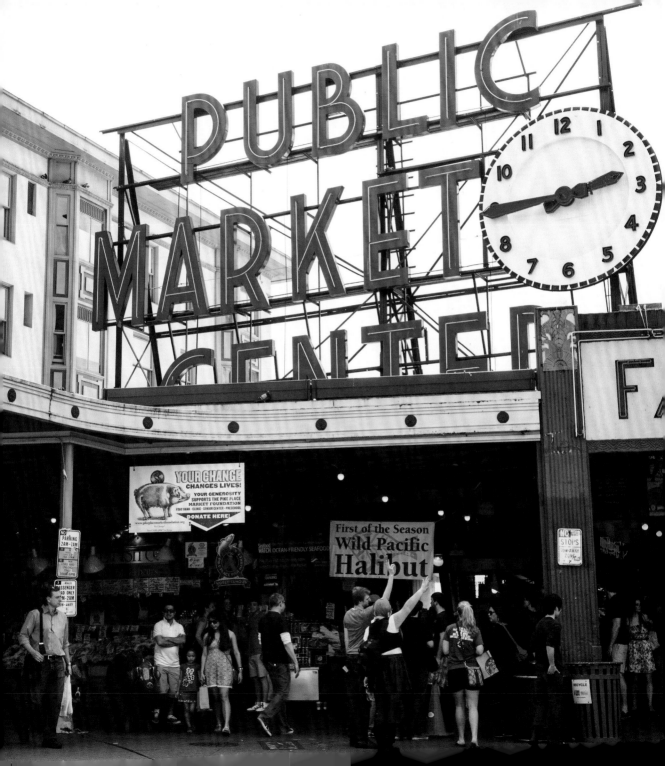

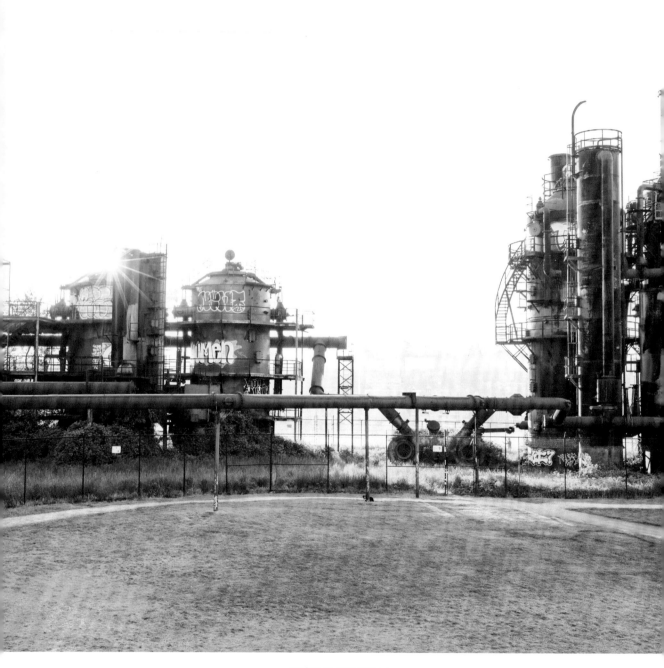

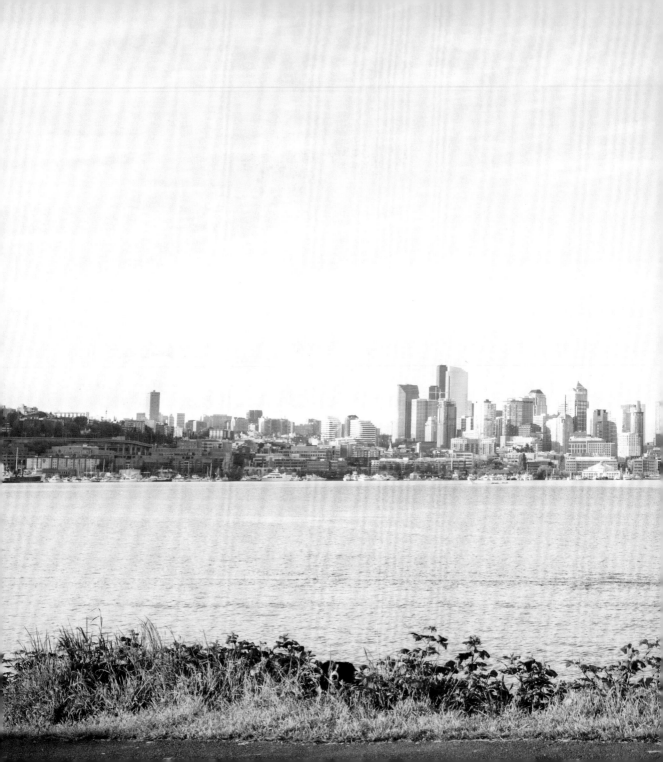

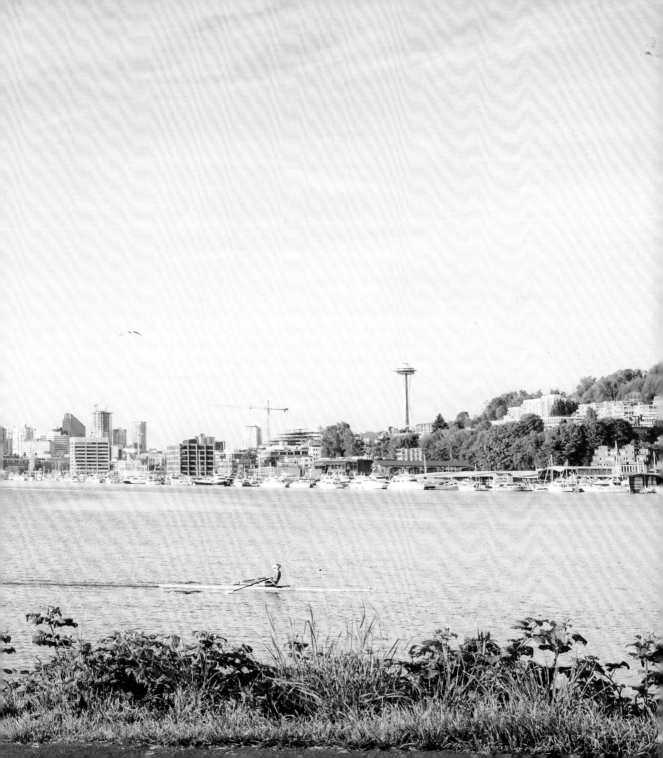

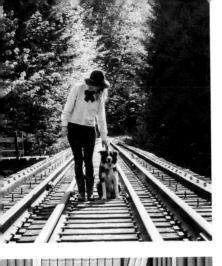
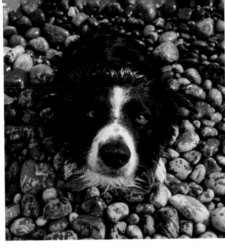

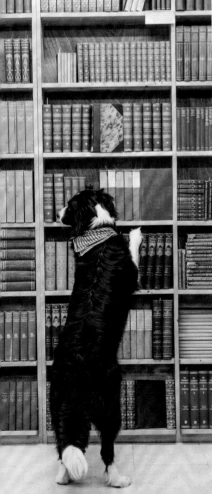

BRITISH COLUMBIA, ALBERTA, AND SASKATCHEWAN

Bellingham, Washington, was our last U.S. stop, and then we slipped back into Canada. This trip was the longest I'd ever been out of the country. I was still 2,500 miles (4,000 km) from Sudbury, but I already felt like I was home.

About a half hour from Calgary, the van broke down. When the tow truck arrived, the driver told us he'd picked up the same type of van at the same spot just a month earlier. Weird.

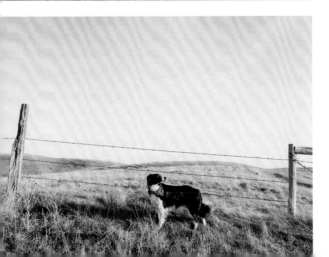

(*opposite, clockwise from top left*) Our friend Katie and Momo exploring a trestle near Nanaimo, BC; Momo at Beacon Hill Park, Victoria, BC; a colorful streetscape in Victoria, BC; our route; two of our stops on the Trans-Canada Highway; inside the Railway Museum in Revelstoke, BC; browsing at Russell Books in Victoria, BC.

British Columbia, Alberta, and Saskatchewan

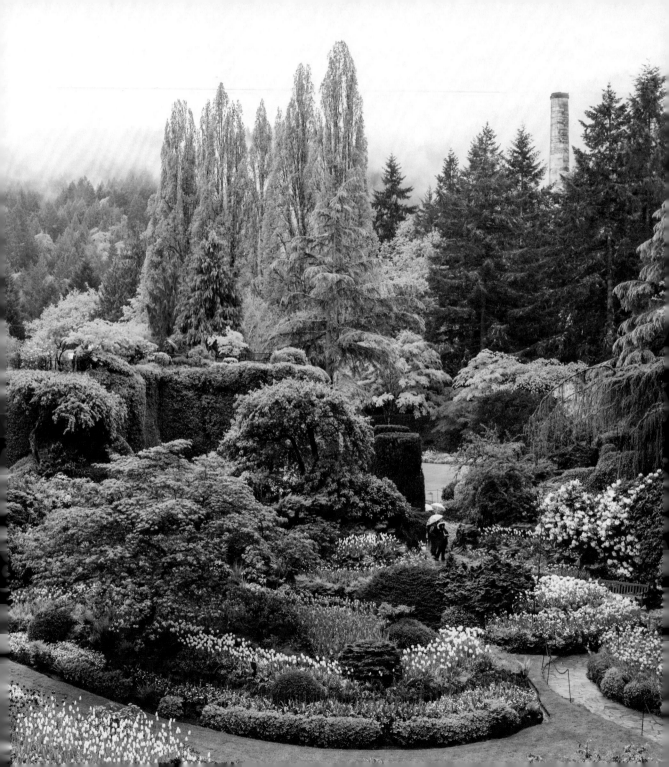

British Columbia, Alberta, and Saskatchewan

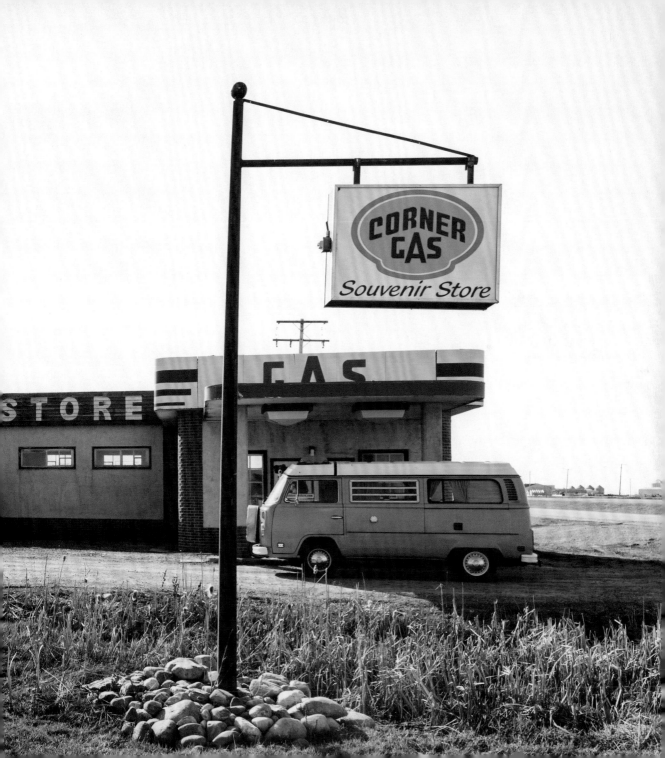

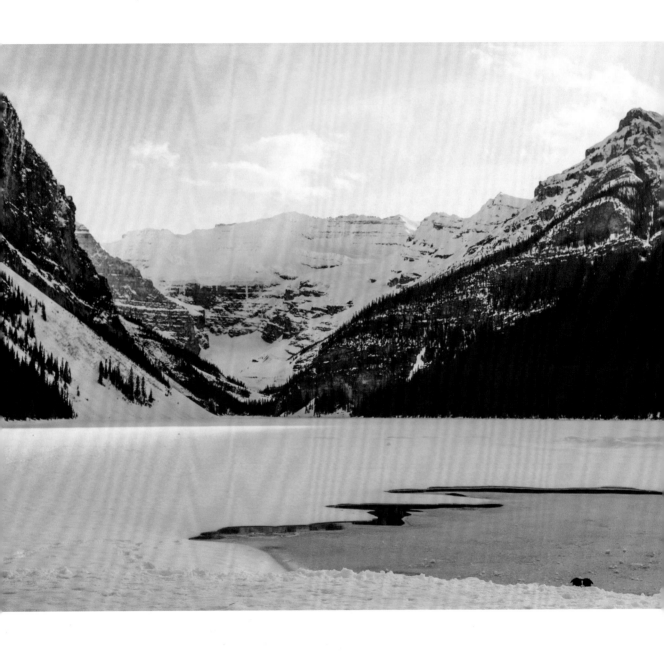

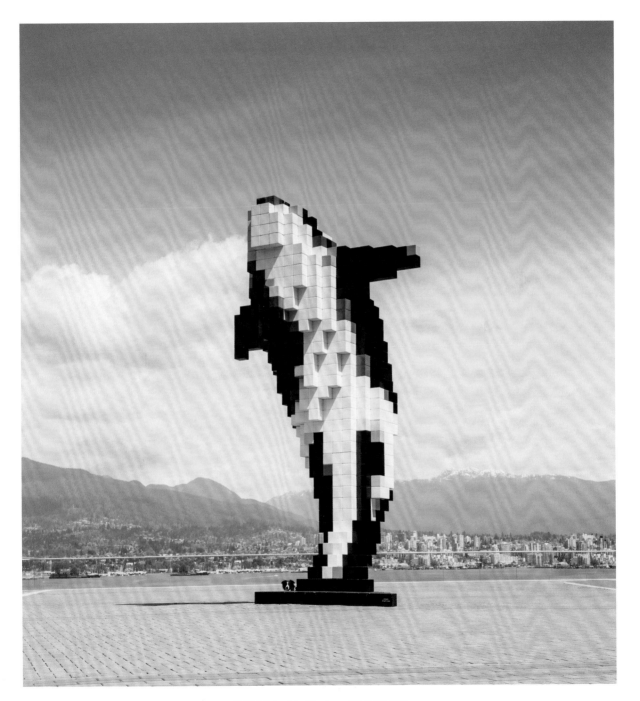

British Columbia, Alberta, and Saskatchewan

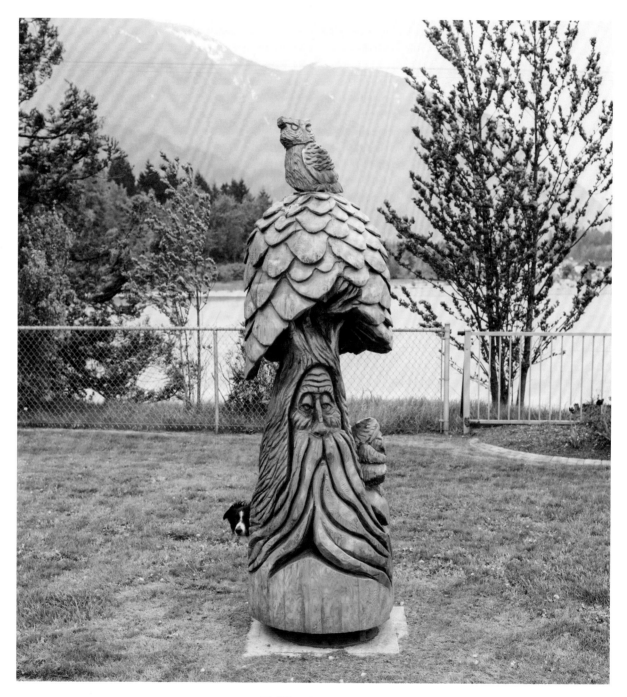

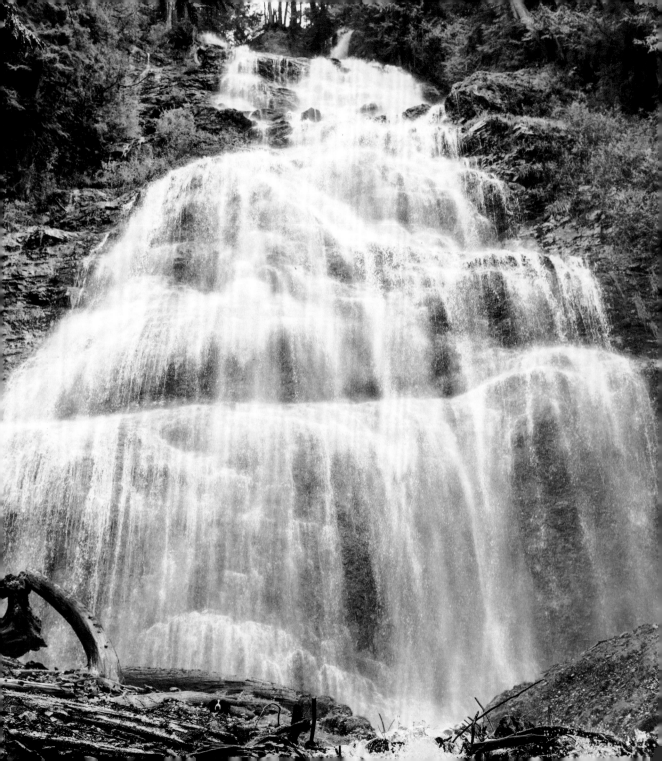

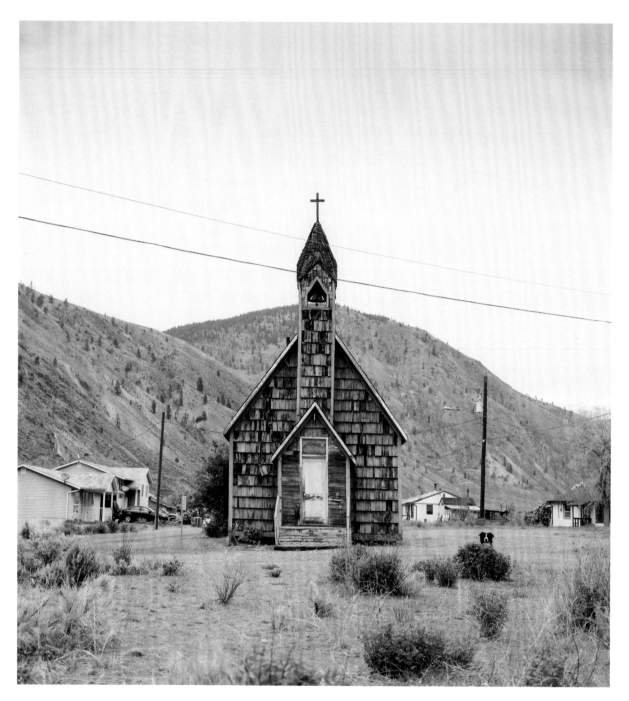

Find Momo Coast to Coast

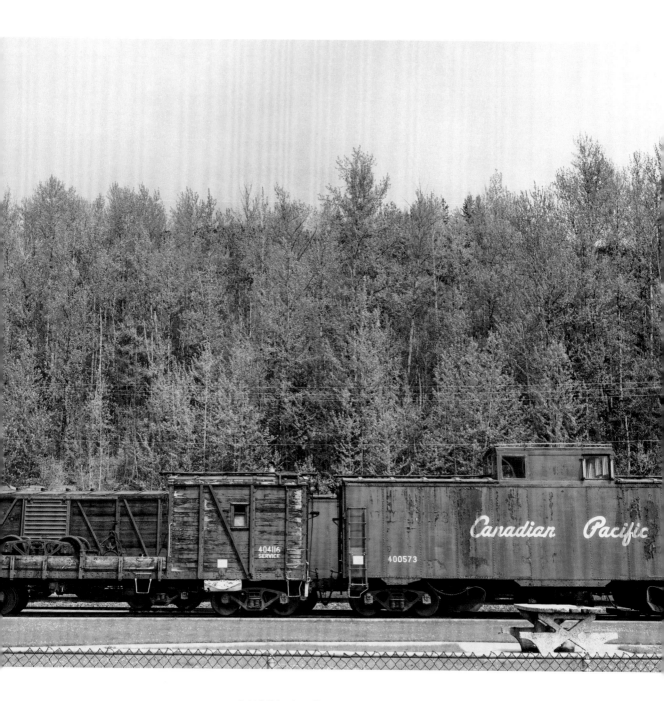

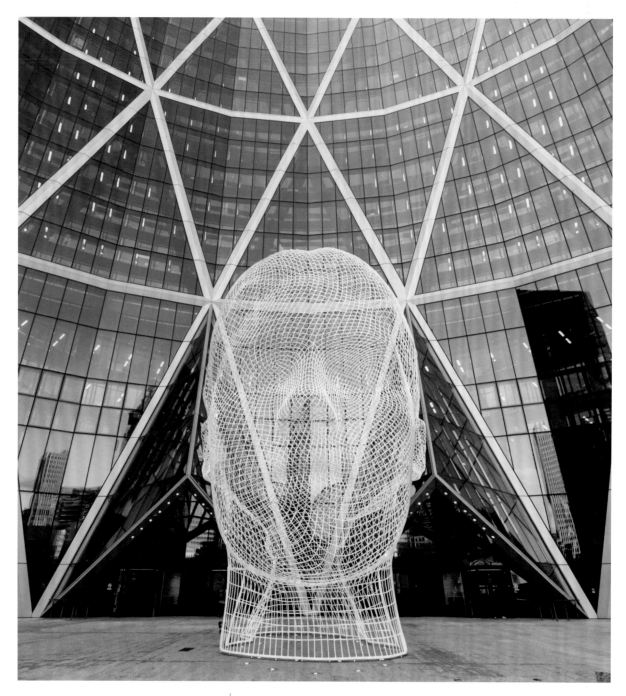

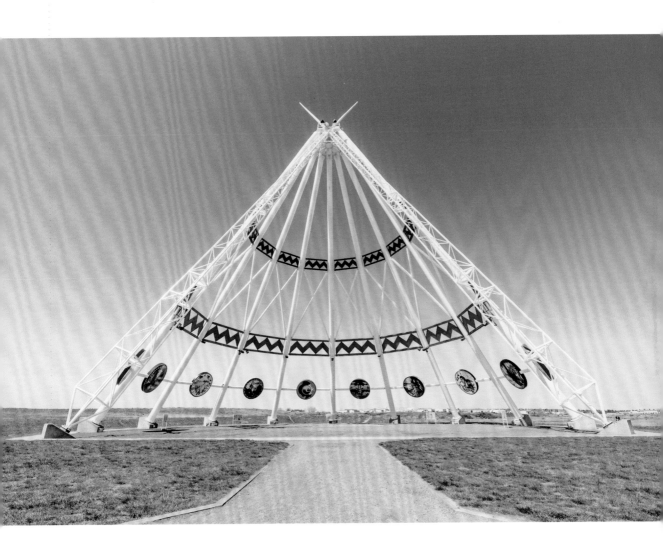

British Columbia, Alberta, and Saskatchewan

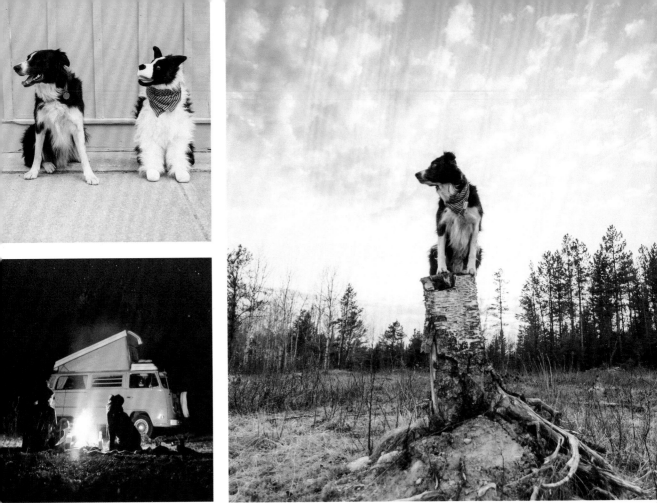
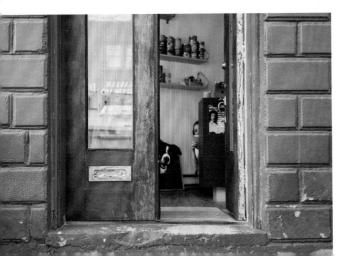
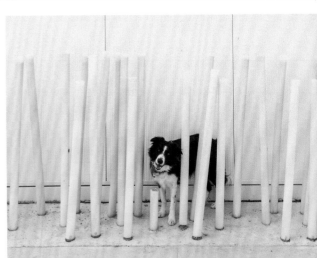

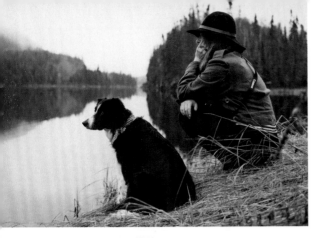

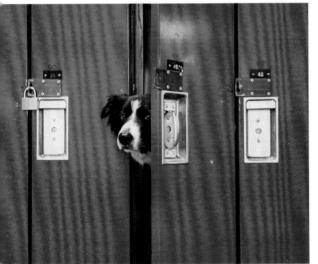

MANITOBA, ONTARIO, AND HOME

Back in my native province of Ontario, our first stop was at a camping spot to meet our friends Katie and Jupiter. We all sat around a fire and passed around some stories. My hometown, the finish line, was near.

The Greek philosopher Heraclitus stated long ago that "no man ever steps in the same river twice." He believed everything was constantly changing, and I agree. When you leave a place for almost a year, it's bound to be different upon your return. I'm always a little nervous for endings and beginnings. Like Momo, I try to enjoy the moment despite unpredictable changes and unexpected surprises.

(opposite, clockwise from top left) Momo with a doppelganger in Creemore, ON; atop a roadside attraction in Ontario; relaxing at Black Fox Lake off the Trans-Canada Highway in Ontario; at the University of Winnipeg; the final leg of our trip; at the Plug In Institute of Contemporary Art, Winnipeg, MB; peeking out from Café Petit Gâteau in Sudbury, ON; camping on Ontario crown land.

Manitoba, Ontario, and Home

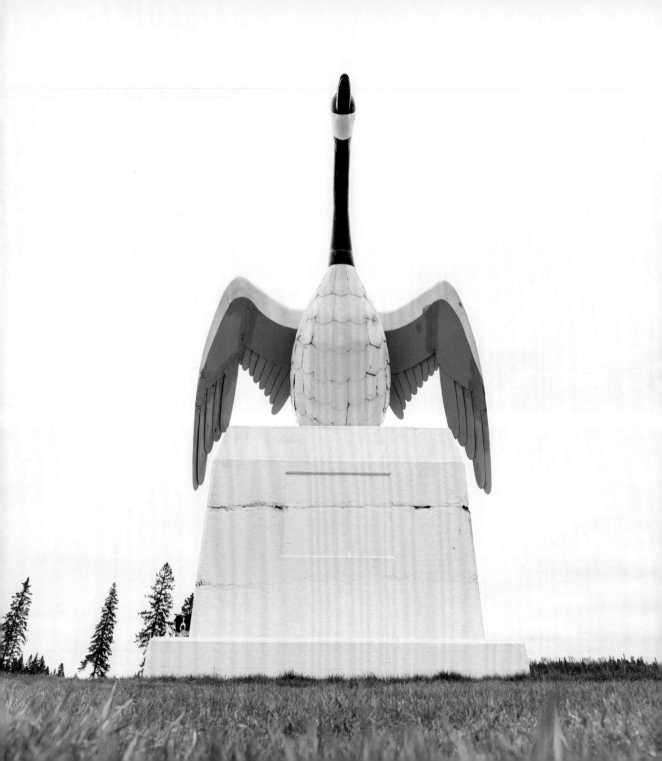

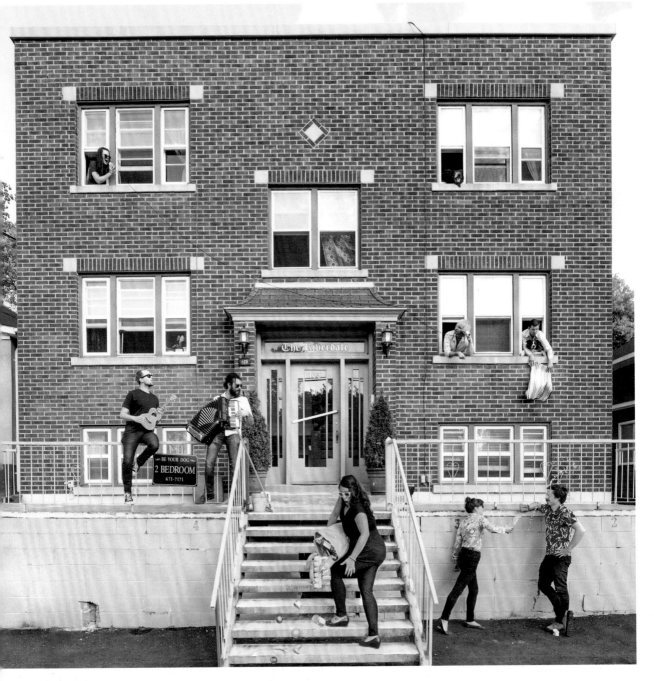

Manitoba, Ontario, and Home

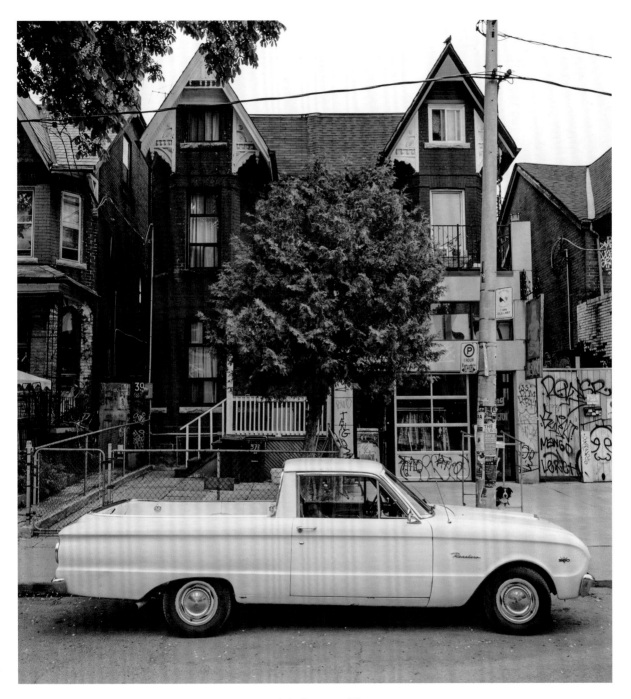

Manitoba, Ontario, and Home

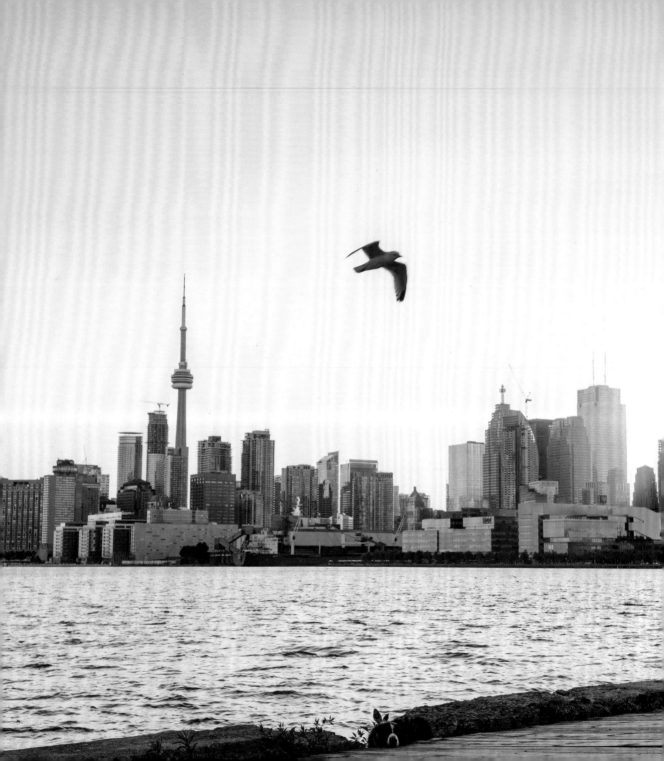

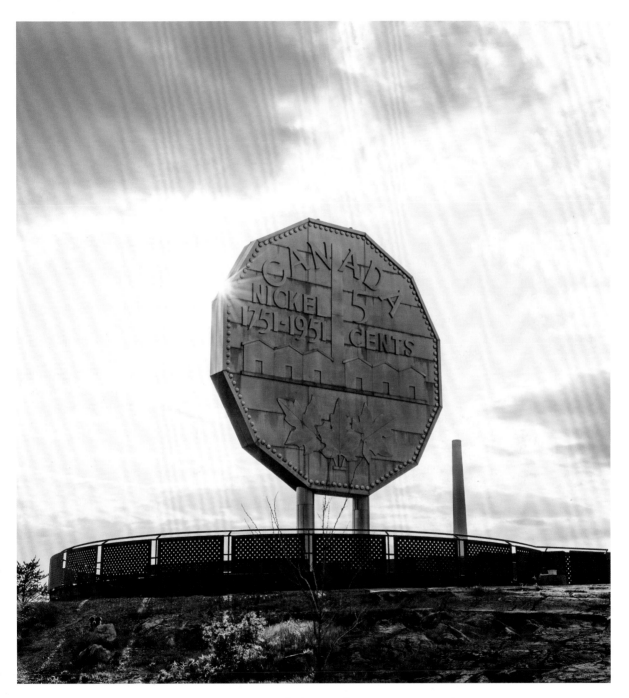

Manitoba, Ontario, and Home

Need help finding Momo?

ANSWER KEY

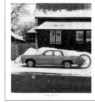

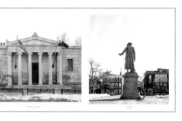

12
Portland Head Light, Cape Elizabeth, Maine

13
Bard Coffee, Portland, Maine

14
Portsmouth, New Hampshire

15
Beacon Street, Boston, Massachusetts. Cara is hiding in this photo as well as Momo. Can you spot her?

16
Lodge at the Bunker Hill Monument, Boston, Massachusetts

17
Statue of Colonel William Prescott at the Bunker Hill Monument, Boston, Massachusetts

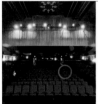
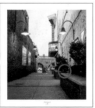

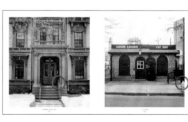

18
Coolidge Corner Theatre, Brookline, Massachusetts

19
Exterior of Coolidge Corner Theatre, Brookline, Massachusetts

20–21
Holy Land, Waterbury, Connecticut. This abandoned religious theme park was reputed to be riddled with apparitions. We wanted to turn back the whole time we were there.

22
Graves-Dwight House, Hillhouse Avenue, New Haven, Connecticut

23
Louis' Lunch, New Haven, Connecticut. The original proprietor of this eatery claimed to have invented the hamburger in 1900.

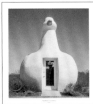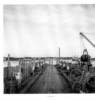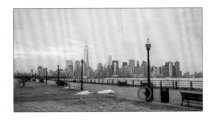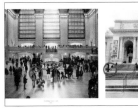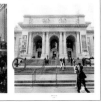

26
The Big Duck, Flanders, New York. This landmark was built in the 1930s by a farmer selling his ducks to passing motorists.

27
Dock in Montauk, New York

28–29
View of Manhattan from Liberty State Park, Jersey City, New Jersey

30
Grand Central Station, New York, New York

31
New York Public Library, New York, New York

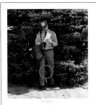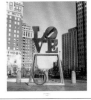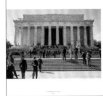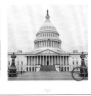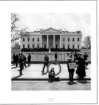

32
Special Delivery by J. Seward Johnson Jr., Ridgewood, New Jersey

33
LOVE Park, Philadelphia, Pennsylvania

34
Lincoln Memorial, Washington, D.C.

35
United States Capitol, Washington, D.C.

36
Washington, D.C.

37
The White House, Washington, D.C.

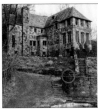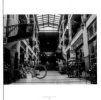

40–41
River Arts District, Asheville, North Carolina

42
Asheville, North Carolina

43
Grove Park Inn, Asheville, North Carolina

44
Grove Arcade, Asheville, North Carolina

45
Asheville Vee Dub, Asheville, North Carolina

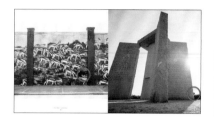

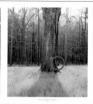

46
I Am Because We Are by Freddy Sam, Atlanta, Georgia

47
Georgia Guidestones, Atlanta, Georgia

48
Mobile Carnival Museum, Mobile, Alabama. Did you know that the U. S. celebration of Mardi Gras started in Mobile in 1703?

49
Butch Anthony's Museum of Wonder, Seale, Alabama

50–51
Union Springs, Alabama

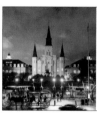

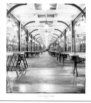

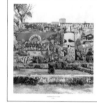

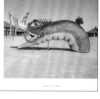

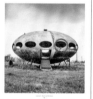

54
Saint Louis Cathedral, New Orleans, Louisiana

55
French Market at night, New Orleans, Louisiana

56
Hope Outdoor Gallery, Austin, Texas

57
Somewhere in Louisiana

58
Adickes SculpturWorx Studio, Houston, Texas

59
Prada Marfa by Elmgreen and Dragset, northwest of Valentine, Texas. This is a permanently installed life-size sculpture.

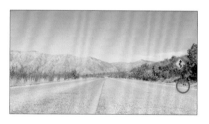

60
U. S. Post Office and Courthouse (aka "Federal Building"), Deco District, Tulsa, Oklahoma

61
320 South Boston Building, Deco District, Tulsa, Oklahoma

62–63
Guadalupe Mountains, Texas

64
Cadillac Ranch, Amarillo, Texas

65
Abandoned Futuro House outside Austin, Texas

66–67
El Cosmico campground, Marfa, Texas

70–71
White Sands National Monument, New Mexico

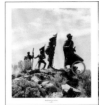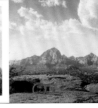

72
La Jornada,
Albuquerque Museum
sculpture garden,
Albuquerque,
New Mexico

73
Sedona, Arizona

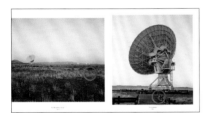

74–75
Very Large Array, Plains of San Agustin,
New Mexico. I've dreamed of visiting these
twenty-seven radio telescopes since seeing the
movie *Contact*.

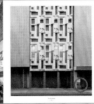

76
Fremont Street, Las
Vegas, Nevada

77
Old Town, Las Vegas,
Nevada

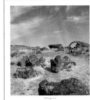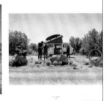

78
Petrified Forest
National Park,
northeastern Arizona

79
Hanging out with
friends in Sedona,
Arizona

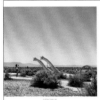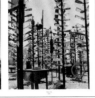

82
Apple Valley, California

83
Bottle Tree Ranch, Oro
Grande, California.
Elmer Long has created
more than 200 of these
unique sculptures.

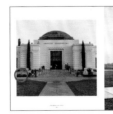

84–85
Griffith Observatory, Los Angeles, California

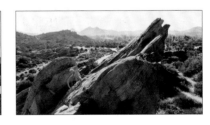

86–87
Vasquez Rocks Park, Agua Dulce, California

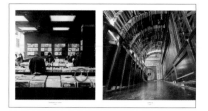

88–89
The Last Bookstore, Los Angeles, California

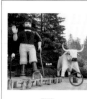

90
Trees of Mystery,
Klamath, California

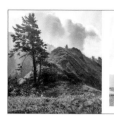

91
Golden Gate Bridge, San
Francisco, California

92
Damnation Creek Trail,
northern California

93
Ventura, California

94
Goorin Bros. hat shop,
Berkeley, California

95
Lombard Street, San
Francisco, California

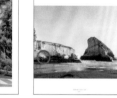
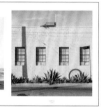

96
Shark Fin Cove Beach,
Davenport, California

97
Los Angeles, California

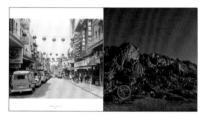

98
Chinatown, San
Francisco, California

99
Camping spot near
Lucerne Valley,
California

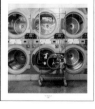

102
Skylark's Hidden Café,
Bellingham,
Washington

103
Spin Laundry Lounge,
Portland, Oregon. A
laundromat with a café
and bar . . . just the kind
of place you'd expect to
find in Portland.

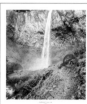
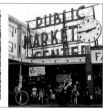

104
Elowah Falls, near
Warrendale, in the
Columbia River Gorge,
Oregon

105
Pike Place Market,
Seattle, Washington

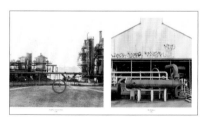

106–107
Gas Works Park, Seattle, Washington

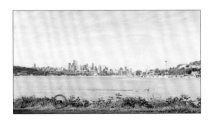

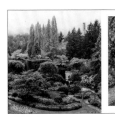

108–109
View of Seattle from Gas Works Park, Seattle, Washington

112
Start of the Trans-Canada Highway in Victoria, British Columbia

113
Crace Mountain, Nanaimo, British Columbia. Katie is a good friend to bring along on a trip.

114–115
Butchart Gardens, Brentwood Bay, British Columbia

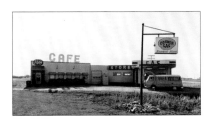
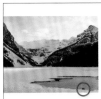
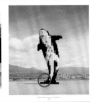

116–117
Set of *Corner Gas*, Rouleau, Saskatchewan. On Highway 39 southwest of Regina stands this faux gas station, which served as the set for the television show *Corner Gas*.

118
Lake Louise, Alberta

119
Digital Orca by Douglas Coupland, Vancouver, British Columbia

120
Chainsaw sculpture by Pete Rieger, Hope, British Columbia

121
Bridal Veil Falls Provincial Park, Chilliwack, British Columbia

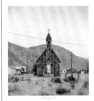
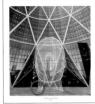
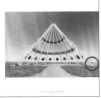

122
Canadian Rockies, British Columbia

123
Railway Museum, Revelstoke, British Columbia

124
Wonderland by Jaume Plensa, outside the Bow Building in Calgary, Alberta

125
Saamis Tepee, Medicine Hat, Alberta. The world's tallest tepee was built for the 1988 Winter Olympics in Calgary.

128
Winnipeg Art Gallery, Winnipeg, Manitoba

129
Plug In Institute of Contemporary Art, Winnipeg, Manitoba

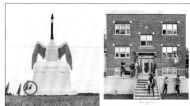
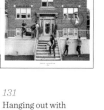
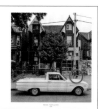
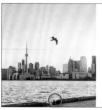
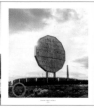
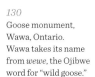

130
Goose monument, Wawa, Ontario. Wawa takes its name from *wewe*, the Ojibwe word for "wild goose."

131
Hanging out with Canadian band Pistol George Warren in Sudbury, Ontario

132
Creemore, Ontario

133
Kensington Market, Toronto, Ontario

134
View of Toronto, Ontario

135
Big Nickel, Sudbury, Ontario. I grew up visiting the Big Nickel. Today it overlooks the Inco Superstack.

THANK YOU

Along the way, I decided to start a list of all the people I'd met who were so insanely generous and welcoming and helpful, but my forgetful side stopped me around North Carolina. I retraced my footsteps and moments, so this list isn't nearly as long as it should be. If you don't see your name and think I should've included it, then it definitely belongs. You have my permission to add your name at the very top of the list. I promise you, I'm no less thankful, only forgetful.

BURLINGTON, VT: Ariel, Tomas, and Pablo. PORTLAND, ME: Longfellow Books. TUFTONBORO, NH: Adrian and Sarah. BOSTON, MA: Kyle and Alyne, Cara and Jason, Brookline Booksmith. NEW HAVEN, CT: Stella and family. MADISON, CT: R. J. Julia. MONTAUK/BROOKLYN, NY: Greg, Lyndsey and Sarah and BillyWolf NYC. RIDGE-WOOD, NJ: Bookends. PHILADELPHIA, PA: Dan; Margaret; Katherine, Rick, Andie, Jane, and all the folks at Quirk Books; Chester County Books. WASHINGTON, D.C.: Books-a-Million. WILMINGTON, NC: Madden; Sarah; Lauren, Zac, and the Freakers; Audrey, Nick, Tom, and Erica; Tattoo Josh; Betsy and Tom. CHAPEL HILL, NC: Flyleaf Books. ASHEVILLE, NC: Chris at Asheville Vee Dub, Rupa and Cheauxchi, Erik, Mara and Garrett, Stepf and Sam, Annie Well, Malaprop's Bookstore/Café. COLUMBIA, SC: Laura and Matt. CHARLESTON, SC: Leslie, Dave and Catherine, Laura, Center, John Stortz, Shelby. SAVANNAH, GA: Erin. ATLANTA, GA: Theron and Maddie, Cami and Rosie, Books-a-Million. NEW ORLEANS, LA: Octavia Bookshop. BATON ROUGE, LA: Michael Tucker. AUSTIN, TX: Emily, Book-people. HOUSTON, TX: Will, Brazos Book Store. TULSA, OK: Laura and Matt, Zoom Room Tulsa. ALBUQUERQUE, NM: Bookworks. TEMPE, AZ: Changing Hands. PRESCOTT, AZ: Chris at Air Cooleds Only. LAS VEGAS, NV: Jessica and Darcy. LOS ANGELES, CA: Teddy; The Last Bookstore; Kate, Kristen, and Sabrina. SAN FRANCISCO, CA: Marian, Maxine Sferra, Nicole and Chudi, Book Passage, Buslab, Jeffrey, Bailey, Scott. PORTLAND, OR: Spin Laundry Lounge. SEATTLE, WA: Erin, University Book Store. BELLINGHAM, WA: Village Books. VICTORIA, BC: Heather and Chris, Russell Books. NANAIMO, BC: Jupiter, Katie. VANCOUVER, BC: Caelie, Black Bond Books. BURNABY, BC: Lee-Ann. REVELSTOKE, BC: Jean-Marc and Keri. CANMORE, AB: Café Books. CALGARY, AB: Leslie and the Kosmik Mansion, Tony's Auto Service, Owl's Nest Books and Gifts. REGINA, SK: Ross (Metro Pet). WINNIPEG, MB: Carly, McNally Robinson. OXDRIFT, ON: Gail and family. THUNDER BAY, ON: Shannon. SUD-BURY, ON: Christian, Jake and staff at Fromagerie Elgin. UXBRIDGE, ON: Blue Heron Books. TORONTO, ON: Zach, Janet and Random House Canada, George Strombo, Mike and Elva, Chris, Jade, Another Story Bookshop. MANOTICK, ON: Ron at VW Restorations. OTTAWA, ON: Maggie, Mike and Ash. EVERYWHERE: Emily and Corey; Roadtrippers app; everyone who hosted an interview, visited me, hung out, or encouraged me along the way, thank you!

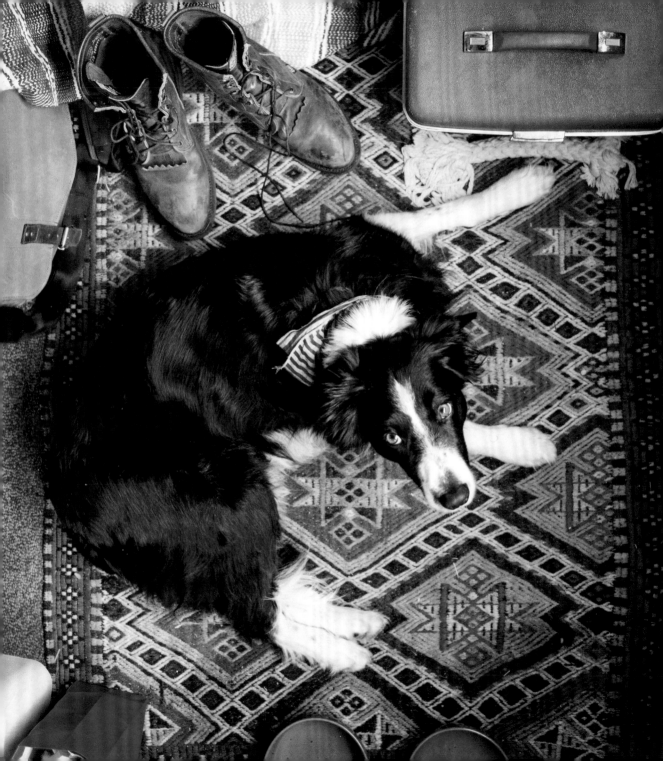